# THE VIEW CAMERA

# THE VIEW CAMERA

## Harvey Shaman

**AMPHOTO**
an imprint of Watson-Guptill Publications
New York

*To Dinny, who has put up with me for too many years to count,*
*and who kept the world off my back while I worked on this book.*

A book involves a great deal of work, and self-doubt often sets in;
fortunately, there are people who have faith in you and help when
the going gets rough. So now is the time to say thank you to: Ron
Lubman, friend, computer expert and mentor, whose help and
patience with me and the insidious device with which I wrote the
manuscript and drew the diagrams made the book a reality;
Calumet Photographic and Bert Velema, managing director of
Cambo, who made available to me an extraordinary amount of
photographic equipment to illustrate the book; Jim McDonald, for
his technical expertise and careful reading of the manuscript; and
Norman Rothschild, Joan Baum, Gustavo Gonzalez, and Len Speier,
whose help and input at the right moments made all the
difference.

Copyright © 1991 by Harvey Shaman
Revised edition published 1991 in New York by AMPHOTO,
an imprint of Watson-Guptill Publications,
a division of BPI Communications, Inc.,
1515 Broadway, New York, NY 10036

Library of Congress Cataloging-in-Publication Data
Shaman, Harvey.
   The view camera.
   Includes index.
   1. View cameras.   I. Title.
   TR258.S44    1991      771.3'2—dc20       90-812
   ISBN 0-8174-6376-3
   ISBN 0-8174-6375-5 (pbk.)

Manufactured in USA

1 2 3 4 5 6 7 8 9 / 99 98 97 96 95 94 93 92 91

# CONTENTS

# INTRODUCTION

The view camera is enjoying a healthy comeback. In the past few years, there has been a renewal of interest in the larger formats and a more contemplative style of photography. This book is designed to clarify any mystery about view cameras for those of you who have never understood how they work.

Although the 35mm single-lens-reflex camera format is still the most popular camera format today, the view camera is gaining wider acceptance and continues to be used extensively by serious photographers. This is particularly true for those who are interested in industrial, architectural, landscape, product, and still-life photography. The reasons are readily apparent if you stop to examine the technical and creative possibilities offered by the view camera. For example, its larger film size can render superior images in terms of reproduction and resolution. This, coupled with a renewed interest in high-quality printmaking, makes the large format an excellent technical option.

Image control with the camera movements is another unique feature. The view camera's rises, falls, slides, swings, and tilts give photographers complete control of image shape, sharpness, perspective, and depth of field. Many people working in 35mm photography are unaware of the visual shortcomings that their equipment imposes upon them. Their visual perspective has been so warped that they accept leaning buildings and misshapen objects in their photographs without question. View cameras aren't limited by these inherent distortions. Their large-format images offer a more precise rendition of the world. Photographs in which the sides of buildings are perfectly parallel and advertising images in which kitchen floors appear crisp and sharp from the foreground to the farthest edge are invariably made with view cameras.

In addition to these technical advantages, the view camera offers the challenge and discipline of a more meditative way of seeing and taking photographs. You must take your time with a view camera. It is not a pop-it-to-your-eye-and-push-the-button machine, which is what many 35mm photographers want when recording the world around them. Essentially stationary and somewhat cumbersome, the view camera isn't adept at capturing the fleeting moment. Working with a view camera forces photographers to take a longer look at the subject and demands a sound understanding of the craft of photography — something many of today's automated 35mm cameras have often supplanted. Yet these very qualities, which almost hastened the view camera's demise as a popular photographic tool, are now seen as its advantages.

In the past, the view camera was an unwieldy device to transport and operate; while these disadvantages haven't completely disappeared, the modern view camera is a very versatile piece of equipment with a wide range of lenses, film, and such accessories as special Polaroid backs and film holders, wide-angle and extension bellows, reflex hoods, behind-the-camera controls, and focusing aids. In fact, the vast array of components available today make the view camera a creative system rather than just a picture-taking machine.

Although models differ from one manufacturer to the next in terms of sophistication and price, all view cameras share the same basic controls and operations. The first-time buyer has an extensive range of options in making a camera selection. To illustrate this book, I chose a medium-priced camera representative of most of the cameras commercially available. Custom models, crafted by specialists in view-camera design, are also available. Shop around, read the literature, and see the variety of models on the market.

This book is arranged to better enable you to see and understand the view-camera equipment and processes. In this completely revised and updated second edition, the material on optics is greatly expanded as is the material on selecting the appropriate lens for any particular photographic situation. The final chapter presents a selection of basic photographic problems and illustrates step-by-step how to incorporate what you have learned to solve them. The combination of text, diagrams, and photographs is designed to give you a solid understanding and command of an extraordinary photographic tool.

The camera shown here is typical of most view cameras. Its principal parts are:

1. *Monorail.* This rigid metal track is the structural support upon which are mounted the lens and back standards and the tripod mounting block. It keeps the various parts of the camera in alignment.

2. *Front Standard.* This usually "U"- or "L"-shaped frame mounts on the monorail. It holds the lens, shutter, and diaphragm assembly and can be locked into any position on the monorail.

3. *Lensboard.* This is a flat plate on which the lens, shutter, and diaphragm assembly are mounted. It is used to attach the lens to the front standard.

4. *Lens.* The lens collects light rays from the subject and focuses the image on the groundglass and film. Its front and rear elements are screwed into the shutter/diaphragm unit.

5. *Shutter/Diaphragm.* This is a combined unit that controls the amount of light striking the film. The shutter consists of a series of blades that open and close to control how long the film will be exposed; the diaphragm is the adjustable-size opening through which the light enters.

6. *Back Standard.* The camera back and groundglass are mounted on this, much like the lens is on the front standard.

7. *Camera Back.* This consists of a frame to hold the cut-film holder and a spring-mounted groundglass, all mounted on the back standard. The spring allows the groundglass to be displaced so that a filmholder can be inserted into the camera back. It can be revolved to make either vertical or horizontal images.

8. *Groundglass.* This is a glazed glass plate upon which the image is focused and composed. Most groundglasses have a vertical and horizontal grid engraved in the glass to aid alignment and composition of the image.

9. *Bellows.* This flexible light-tight tube mounted between the lens and back standard permits the two standards to be moved closer or farther apart for focusing. The bellows makes it possible to use different focal-length lenses while maintaining light-tight integrity between the lens and the camera back.

10. *Spirit Levels.* Double levels, mounted on both front and back standards, are used to ensure that the camera is completely level in the neutral position before any settings or adjustments are made to any of the controls.

11. *Calibrated Scales.* All controls that allow the lens or back standards to slide, rise, or fall are calibrated in graduated millimeters or inches. Those for the swings or tilts are graduated in degrees. These permit you to precisely control or repeat camera adjustments.

12. *Geared Focusing Blocks.* These are used to attach the front and rear standards to the monorail. The gearing allows very precise positioning of both the lens and camera back or the monorail.

13. *Tripod Mounting Block.* This is used to mount the camera on the tripod. The camera monorail can be shifted forward or backward on this block for precise balance or to move the camera closer or farther from the subject along its optical axis.

14. *Tripod Head.* This is the top part of the tripod. It can be tilted from front to rear and from side to side, as well as rotated in different directions.

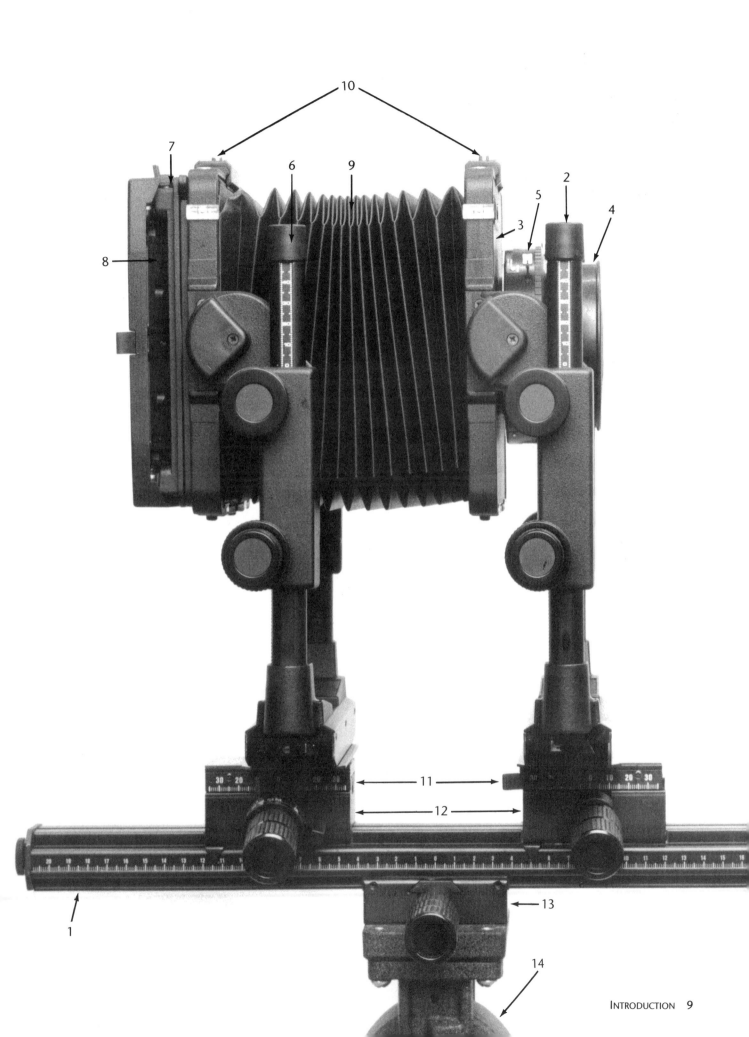

## Chapter One
# EQUIPMENT AND ACCESSORIES

A wide variety of cameras and ancillary view-camera equipment is available. All manufacturers design their cameras and accessories to their own specifications. Consequently, no two cameras or accessories are exactly alike, but most will have the same type of controls and functions. Generally, the differences between camera models involve the range of movement they offer, the precision of workmanship, the quality of the materials from which they are made, and the sophistication of the camera's design.

The basic view camera consists of a rigid *monorail*, or track, upon which are mounted movable *front and rear standards*, or supports. The lens is mounted on the front standard, and a

*groundglass* used for focusing and composing the picture is mounted on the rear standard. These elements are interconnected by a flexible, light-tight *bellows*.

Both the lens and rear standard can be pivoted around their axis, raised, lowered, swung, or slid from side to side to change the relationship between the lens and the film. These movements enable the photographer to control the shape of the subject and the plane of focus with great precision. On most view cameras, the lenses, backs, bellows, and even the monorail track are modular and interchangeable, so specialized accessories can be attached for various photographic situations.

*This side view of a view camera shows how the front and rear standards are mounted on the monorail.*

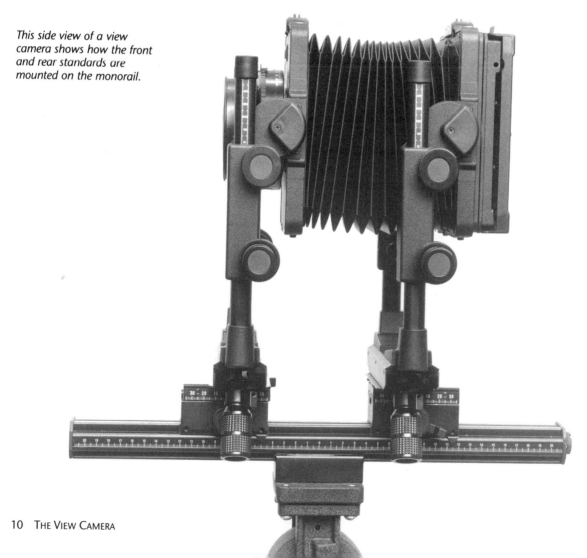

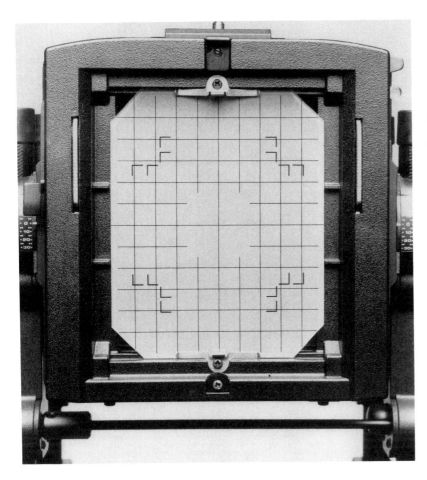

*In this closeup rear view of a view camera, you can see the groundglass, which enables you to align the image.*

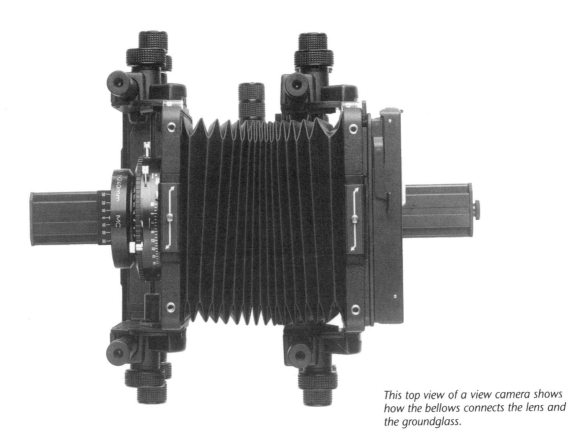

*This top view of a view camera shows how the bellows connects the lens and the groundglass.*

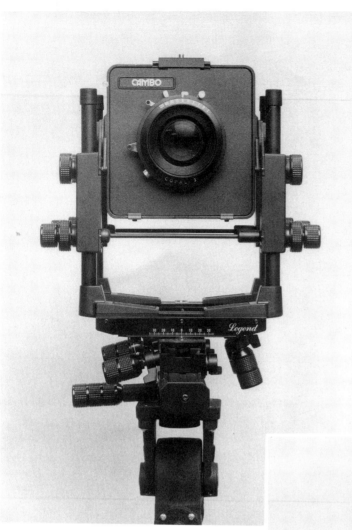

These front and rear views of a Cambo view camera show the controls and knobs used for the various camera movements. Once the camera is adjusted properly, it must be locked into position.

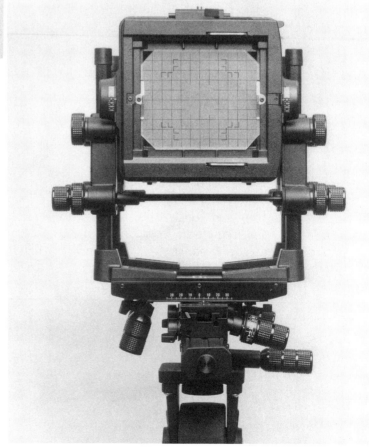

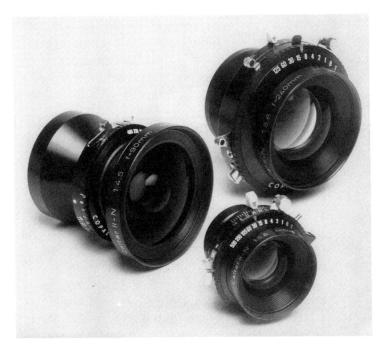

*These three basic focal-length lenses for 4 x 5 view cameras are the 90mm wide-angle lens (left), the 150mm normal lens (center), and the 240mm long-focus lens (right).*

# CAMERAS

View cameras come in a variety of sizes, ranging in inches from 2¼ × 3¼ up to 11 × 14 formats. There are larger models, but those are usually used only for special-purpose photography because of the limits imposed by their massive size and weight. The two most popular sizes are 4 × 5 and 8 × 10.

All monorail cameras are modular in design. These can be specifically configured in terms of bellows, monorail length, and type of back and front components to serve a wide variety of photographic needs.

Fundamentally, there are two basic view-camera designs: the *monorail*, or *optical-bench*, camera, and the *flat-bed*, or *folding*, field camera. The optical-bench camera consists of a rigid metal bar upon which are mounted a front standard that holds the lens and a rear standard that holds the groundglass and film. The field camera is designed so that the front and back are mounted on a flat-bed platform. This is usually made of wood and can be folded for compactness and portability. Unlike the optical-bench model, the bellows on a field camera isn't normally interchangeable, and there are a limited number of accessories available for it.

There are several basic camera-design approaches to tilting the front and back of the view camera in relationship to the track or bed.

The most widely used design incorporates a center tilt, which allows both the lens and film to pivot around their center axis. One advantage to this is that once a subject is in focus, tilting either the lens or groundglass causes little or no shift in the plane of focus, so adjustments are minor. Second, because the distance between the lens and film doesn't change, there is little variation in image size. Another solution places the pivot point for the lens and groundglass tilts at the bottom of the lens and film standards instead of at their center axis. This allows for much greater tilts of the film and groundglass than are possible with center tilts. But this bottom-pivot design has drawbacks. Primarily, when the lens or film is tilted, the distance between them changes, and it becomes necessary to refocus. The tilted lens or film also shifts the image off the horizontal axis, making it necessary to raise or lower the groundglass in order to recenter the image.

A third camera design incorporates a combination of both center and base tilts. This is used to help correct the problem of *adverse yaw*, an optical misalignment that results when the camera is tipped up or down while the back is rotated around its mechanical axis. This combination design requires a sophisticated and expensive mechanism that only top-of-the-line models incorporate.

## 4×5 Camera

This is the most widely used view-camera format available today, and it is considered the standard. The 4 x 5 format is large enough to produce a large negative or transparency, yet is portable enough to be taken on location. Most manufacturers produce a variety of models in this size, and the greatest range of accessories and supplementary equipment is available as well.

## 8×10 Camera

This popular-format view camera is generally used in the studio because of its weight and the need for a heavy studio stand or tripod to hold it. The primary advantage of using a camera this size is the large image it produces on 8×10 film, which is essential when fine detail or extreme enlargement is necessary. The front standard on an 8×10 camera is the same as that used on the 4×5 camera, although the lens focal lengths are appropriate for the larger film size. Because of its bellows' length and bulk, a central support is generally needed to keep the bellows from sagging and intruding into the path of the light.

## "L"-Standard Monorail Camera

This variation on the monorail camera utilizes an "L"-shaped standard instead of the "U"-shaped lens and back standards. It has all the swing, tilt, rise, fall, and shift controls as the regular camera. A major advantage of this model is that the swing and tilt mechanisms have unlimited movement because there are no restrictions imposed by the side of the "U"-shaped lens and back standards. Generally, this design is found in cameras that also incorporate gearing of all mechanisms for easier and more precise adjustments.

## Multi-Tilt "L"-Standard Monorail Camera

This advanced version of the monorail camera incorporates several additional controls, including a base tilt for both the front and back standards. When a camera is pointed up or down, the standards are no longer directly over their central pivot points. Consequently, if the back is tilted upright in order to control parallel lines in the subject and is then swung, it no longer rotates around this pivot axis. Instead, it swings in an arc, which causes it to lean to one side, resulting in adverse-yaw distortion in the groundglass and final image (see page 97). With a base tilt, once the camera has been pointed either up or down, the lens and back can be tilted upright from the base rather than from the lens pivot point. This puts the groundglass directly over the central pivot point so that it rotates around the pivot. This eliminates adverse-yaw distortion.

A second refinement is an advance-tilting mechanism for both the lensboard and the camera back. In most cameras, the lens and groundglass have center tilts; in this model, the tilt can be adjusted so that it is off-center. This allows very precise and smooth positioning of the plane of sharp focus.

*The 8 x 10 view camera produces an impressive size negative that records fine detail with the utmost clarity.*

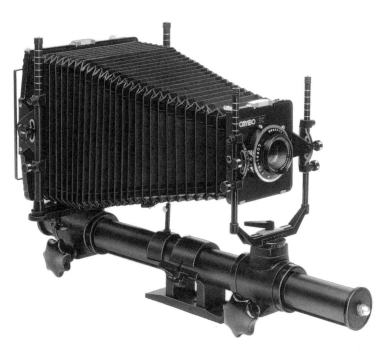

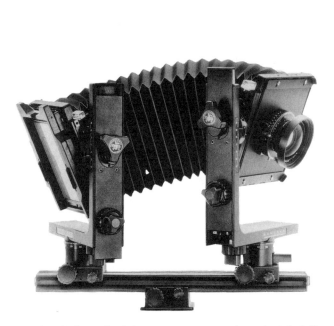

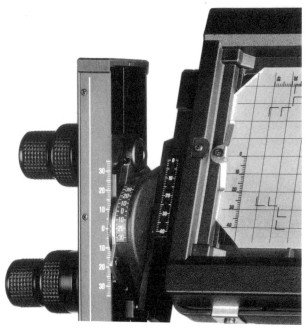

Modern ''L''-standard view cameras are sturdy and retain full movements with little bulk.

The most advanced camera movement on top-of-the-line view cameras is an additional adjustment for off-center positioning of the horizontal pivot point of the lens and groundglass. This makes it easy to precisely position the plane of sharp focus.

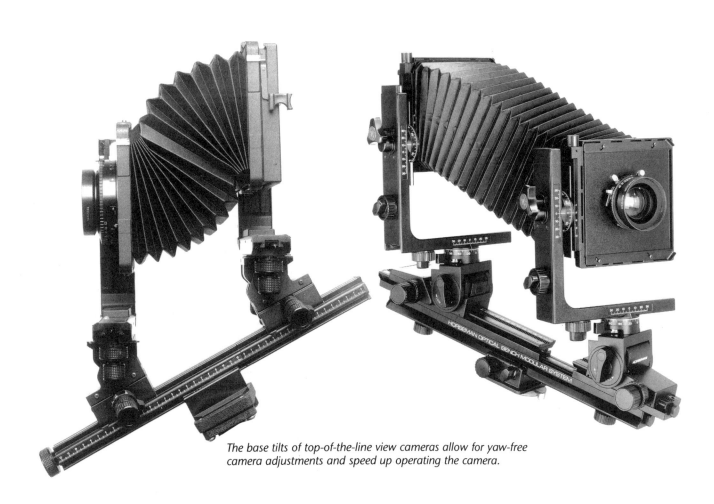

The base tilts of top-of-the-line view cameras allow for yaw-free camera adjustments and speed up operating the camera.

### Field Camera

This version is usually made of wood and is lightweight and compact for ease of transportation. The bellows compresses so that the bed can be folded up, making the camera a small, self-contained box with the lens inside. Because of the compactness of these cameras, some of the adjustments that are available on monorail view cameras are left off. Most often this is the ability to raise and lower the camera back. However, there is still a rising and falling front that allows the shifting of the image position on the film.

### Technical Camera

This hybrid design has the folding metal body of the older press cameras, coupled with an extensive range of modern view-camera movements. The back both swings and tilts via a supplementary rear bellows and extension arms. The lens standard has rise, fall, slide, swing, and tilt movements, so corrections for shape and the control of sharp focus are possible. Although these cameras don't come with an interchangeable bellows, it is possible to use long lenses or make extreme closeups because of the extendable track and extra-long bellows. In addition, wide-angle lenses can be used by dropping the bed down so that it doesn't intrude in the picture frame. On some models a built-in rangefinder allows you to focus without having to put the camera on a tripod and use the groundglass.

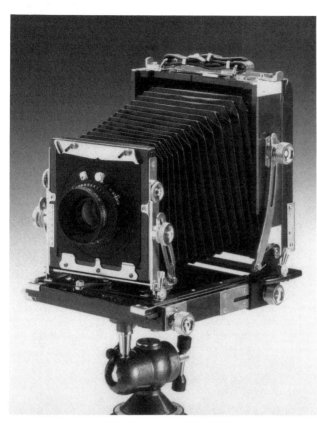

*Most field cameras are made of fine woods and brass, have high-quality bellows, and are sturdy and lightweight.*

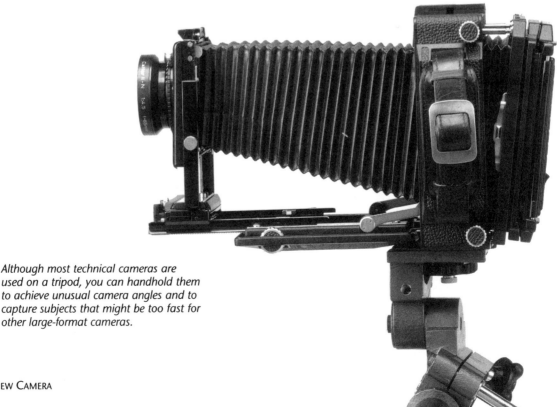

*Although most technical cameras are used on a tripod, you can handhold them to achieve unusual camera angles and to capture subjects that might be too fast for other large-format cameras.*

# VIEW-CAMERA ACCESSORIES

The modern view camera isn't a single unit. It is a series of components that, in combination, enable you to manipulate and solve problems of image control and focusing. Accessories either add to the camera's flexibility and ease of operation or allow you to make pictures that couldn't otherwise be made with the normal camera components.

While the basic camera is extremely flexible, the various components often need additional accessories for a particular situation. For instance, if you're photographing a very large subject, you may find it necessary to use a wide-angle lens in order to get everything into the picture. With a wide-angle lens on the camera, the normal camera bellows may be too cumbersome to allow you to use the camera's swings and tilts. Therefore, it would be necessary to switch to a wide-angle bellows that is less bulky in order to use these camera movements.

## Tripods

These come in a variety of sizes and weights, and they should be matched precisely to the particular camera they will be required to support. Most have several leg extensions as well as an elevating centerpost for height adjustments. Many are available with accessory side arms or an accessory short centerpost so the camera can be positioned near the floor or offset to shoot straight down without having the tripod legs intrude in the picture.

Stability is an important feature in selecting a tripod. It must be able to hold the camera's weight safely and be vibration-free at the moment of exposure, or all your efforts will be wasted. For this reason, select the heaviest, most stable tripod you can find. Keep in mind that if you travel or shoot a great deal on location without an assistant to help move equipment, a lighter (but less stable) tripod may be necessary; however, in no instance should a camera be used on a lightweight tripod, regardless of the inconvenience of carrying heavier gear. The important consideration is to not risk losing a picture due to vibration inherent in an unstable tripod. Using the wrong equipment is no excuse for an unsharp picture.

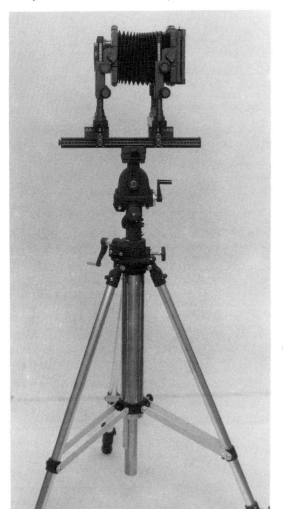

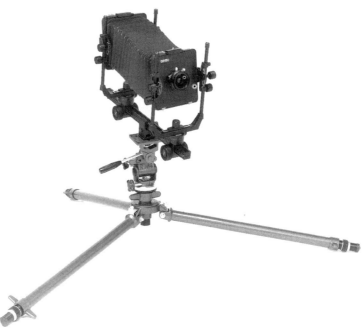

*A sturdy tripod (left) that provides complete stability is essential; without one, sharp pictures are impossible. To achieve low angles with view cameras, you need to use a tripod that has both legs that can be spread quite far and a special short centerpost (above).*

Flexibility is another important consideration. How high can the tripod raise the camera? How low? Can you shoot straight up or straight down? To shoot straight down, you may sometimes find it necessary to use a side-arm attachment to get the camera away from the tripod's centerpost. This situation is always unstable; you will be suspending a heavy, yet delicate and expensive camera in midair when it is mounted on a side arm, so you can't afford to take chances.

Having the option of an elevating centerpost lets you raise or lower the camera and position it precisely. It should be crank-activated for accuracy and control in raising and lowering the camera. In addition, it should have positive locks so that the camera won't slip out of position. Also, the tripod should have some safety feature, so if the lock is not engaged or the crank slips, the camera won't drop to the bottom of the elevator and be damaged by the sudden stop.

The tripod head should have a large base platform for screwing the camera on safely and for locking it down securely. The head should be able to swivel smoothly. The head's tilt mechanism should be crank-activated for accurate control in pointing the camera up and down, and it should include a roll control for leveling the camera from side to side.

Operation of each control should be independent of the others; one change in control shouldn't result in another part moving and changing something else. On some tripod heads, roll and tilt are combined in a single control. This isn't good because it is almost impossible to make fine adjustments in one direction without affecting the adjustments in another, particularly when a heavy camera is mounted on the tripod.

Some tripods come with a bubble level, a useful device when the ground is uneven. This is important because all the camera movements are predicated on starting with the camera level and all controls in the neutral position before any adjustments are made.

Non-slip locks ensure that once the camera is positioned properly, it won't accidentally slip out of the desired position. All tripods use either knurled rings or levers to lock the controls. These non-slip locks are designed so that only gentle pressure is needed in order to produce a positive grip. Don't force them—overtightening can damage the mechanism.

## Cut-Film Holder
This light-tight device holds two individual pieces of film, one on each side. A dark slide on each side ensures that the film is kept light-tight until the holder is inserted into the camera back. The slide is marked so you can tell if the film in it is exposed or unexposed: one side of the top of the slide is black, and the other is white or silver and has a series of notches or bumps on it. When the film is loaded into the holder, the silver side of the slide should be out. The notches or bumps on the slide are used for positive identification in the dark when the film is being loaded into the holder. This indicates that the film inside is unexposed. After you insert the holder, the dark slide is then removed. After the exposure has been made, the slide is reinserted black-side-out. This indicates that the film is exposed.

## Roll-Film Holder
This holds either 120 or 220 roll-film sizes and is inserted into the spring back in place of the regular cut-film holder. The format is $6 \times 7$cm ($2\frac{1}{4} \times 2\frac{3}{4}$ inches) and yields either 10 or 20 exposures. The holder has a frame counter to show the number of exposures made and a dark slide so that the holder can be removed after each exposure to check focusing and composition.

## Polaroid Sheet-Film Holder
Individual sheets of $4 \times 5$ Polaroid film may be exposed and processed in this self-contained unit. It slips into the back of the view camera in the same manner as the regular cut-film holder. A full range of Polaroid films is available in this format.

## Roll-Film Holder with Sliding Back
This accessory combines a groundglass and roll-film holder in a single unit. It is substituted for the normal groundglass back. Once the picture is composed and focused on the groundglass, the roll-film portion is slid into position behind the lens. One model even has a built-in dark slide that is automatically withdrawn when the film holder is positioned. The groundglass is ruled with vertical and horizontal gridlines for use in either a vertical or a horizontal format. The holder has a built-in frame counter and is designed for 120 film. It is operated with a single-stroke film-advance lever with an automatic stop.

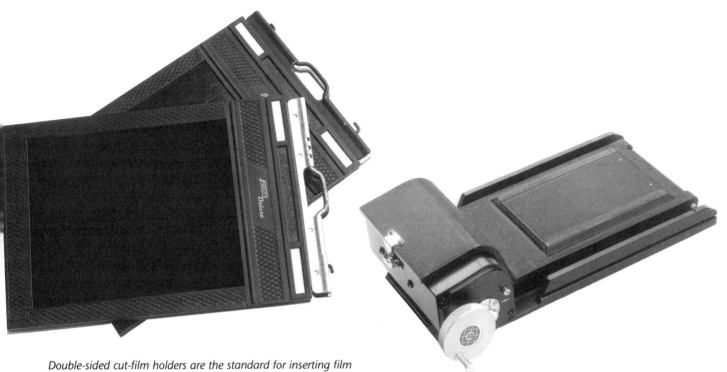

Double-sided cut-film holders are the standard for inserting film into the view camera.

When a smaller film size is practical, a 120 roll-film holder can be substituted for the 4 x 5 holder.

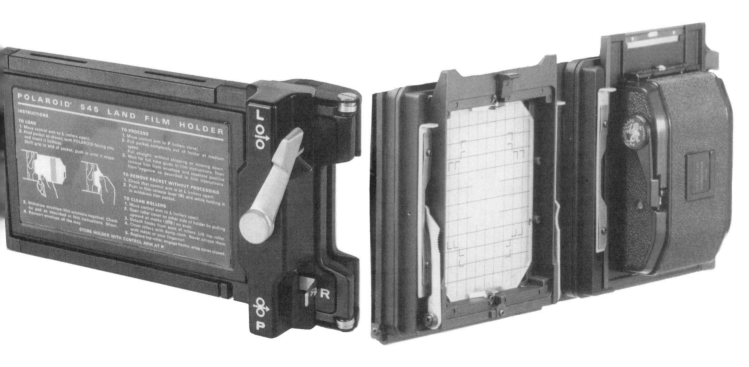

Polaroid sheet-film holders enable you to make test photographs for subject positioning, and lighting arrangements and balance.

A combination roll-film and groundglass back speeds up operating the camera and reduces the chance of shifting the back out of position when you insert a different type of holder.

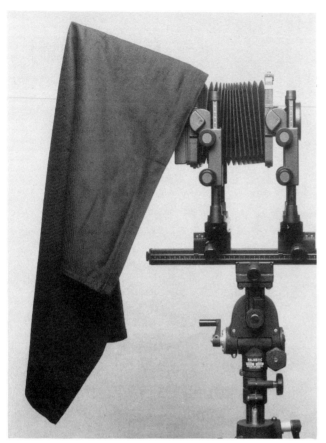

*Without draping a dark cloth over your head while shooting, you'll find that it is almost impossible to see the image or to properly adjust the view camera.*

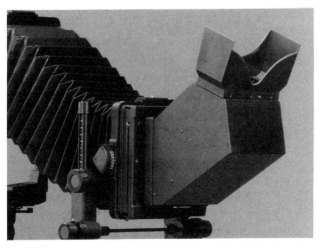

*A modern, more convenient version of the dark cloth is the reflex viewer.*

## Focusing Cloth and Wire-Frame Holder

This simple wire frame and dark cloth is one of the most useful view-camera accessories. The frame clips into the camera's rear standard, and a black cloth is draped over it to form a tent around the back of the camera. Without this accessory, composing and focusing in bright light would be difficult because extraneous light reflected from the surface of the groundglass would wash out the image projected by the lens. The frame holds the cloth over the camera's back, giving you plenty of room to manipulate camera controls in the darkened environment.

## Mirror-Reflex Viewer

An adaptation of the reflex mirror found in standard reflex cameras, this helps overcome the problem of working with the inverted and reversed image on the groundglass. The mirror erects the image so that you see it upright, although the image is still reversed from side to side. The reflex mirror incorporates a spring back, making it possible to insert the film holder without removing the reflex mirror from the camera. The back can be rotated 90 degrees for both vertical and horizontal formats. A magnifying eyepiece facilitates focusing and the viewing of the groundglass image. When this is used on the camera, you don't need to use a dark cloth for focusing because the unit itself keeps extraneous light off the groundglass.

## Film-Plane Exposure Meter

This slides into the back of the view camera in place of a regular cut-film holder. It measures the light over the full $4 \times 5$ frame and gives an integrated reading, including automatic compensation for bellows extension and filter factors. This exposure meter has both high- and low-range sensitivity settings to help measure the light even when there is extreme bellows extension and small apertures.

## Wide-Angle Bellows

This short bag-like bellows can be substituted for a normal bellows when you use a wide-angle lens or when extreme camera movements are needed. A normal bellows has so much material in it that it limits the camera's full range of movements or prevents a short focal-length lens from being focused at infinity.

## Short Monorail

This is used in conjunction with the wide-angle bellows and wide-angle lenses. When a wide-angle lens is used, the standard monorail extends so far in front that it shows up in the picture. If you move the lens and back standard forward until the rail no longer shows, the long segment of rail sticking out behind the camera makes it difficult to get close enough to the groundglass to focus or compose.

## Extension Bellows

This is needed when you use long focal-length lenses or do closeup photography and photomacrography because the lens must be positioned at a great distance from the film in order to focus on small objects. The center of the extension bellows must be supported to keep it from sagging into the path of the light.

## Long Monorail

Supplementary monorail extensions or extra long rails are available for all cameras and are used in conjunction with the extension bellows.

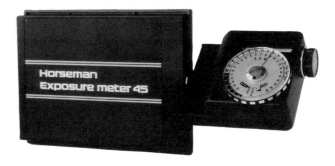

*This type of meter provides 35mm simplicity when you determine exposure settings on a large-format camera.*

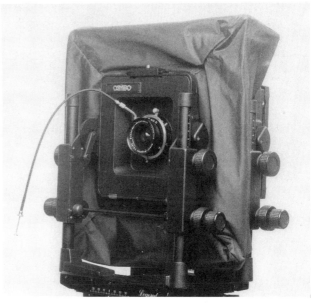

*The bag bellows provides much greater camera flexibility than a regular bellows for both normal and wide-angle lenses.*

*Because of the length of the extension bellows, it sags into the path of the light from the lens to the film if you don't use a central support.*

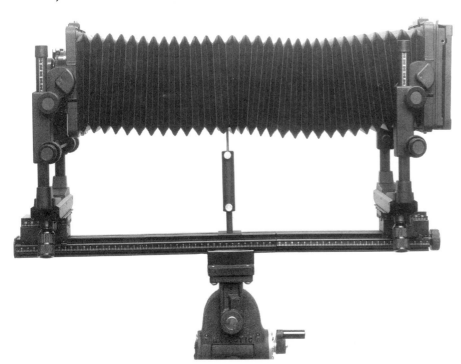

*Lens design often results in unusual shapes and sizes to achieve the desired effect with a 4 x 5 view camera. Here, you see a normal lens (left), a wide-angle lens (center), and a long-focus lens (right).*

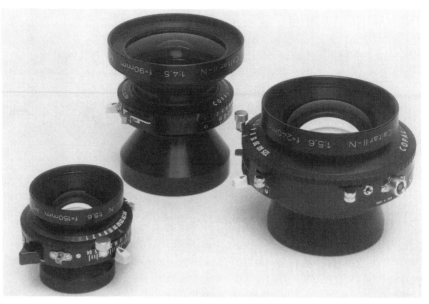

*Extreme wide-angle lenses require the use of a recessed lensboard and a swivel cable-release adaptor.*

## Lenses

The view camera lends itself to a full complement of lenses. The most appropriate focal lengths for the 4 x 5 camera are the 90mm wide-angle lens, the 150mm normal lens, and the 240mm long-focus lens that gives a bigger image and a flatter perspective than the normal lens. Lenses are mounted on the lensboard attached to the camera's front standard. View-camera lenses are modular units containing the diaphragm, shutter mechanism, and flash synchronization connections for both conventional flash bulbs and electronic flash. In addition, most lenses have a press-focus lever that allows you to open the shutter for composing and focusing without having to set the shutter on "T" (time exposure) or to hold it open with a locking cable release.

## Recessed Lensboard

Extreme wide-angle lenses must be very close to the film plane in order to focus at infinity. Because of the size of the lens standards and the thickness of the bellows, a recessed lensboard is often necessary in order to get the lens close enough to accomplish this.

## Swivel Cable-Release Adaptor

The depth of the recessed lensboard and the large size of the shutter/diaphragm mechanism make access to the controls difficult. The cable-release adaptor relieves tension from the lens' cable-release socket and makes it easy to attach a cable release without removing the lens from the lensboard.

## Behind-the-Camera Controls

Modern shutter/aperture mechanisms allow the lens and shutter to be controlled from behind the camera. They can be preset and adjusted so that when the film holder is inserted, the shutter closes and the aperture stops down to the proper opening size.

## Compendium Bellows

This is a flexible lens shade that mounts on the front standard. A scissors mechanism at the top of the bellows allows the unit to be twisted in any direction to ensure that the maximum amount of extraneous light is shielded from the lens. The compendium bellows is held on the front of the camera by simple spring tension. It has an adjustable holder for filters, and it can be swung out of the way and then precisely swung back into position after all camera settings have been completed. A compendium bellows helps increase contrast and color saturation by cutting down on extraneous reflections.

## Filter Holder

Filters mounted in this frame are held in front of the camera lens by clamps in the compendium bellows. It holds 3 × 3-inch filters for a wide variety of effects, from contrast control when you use black-and-white film to color correction and compensation when you shoot color.

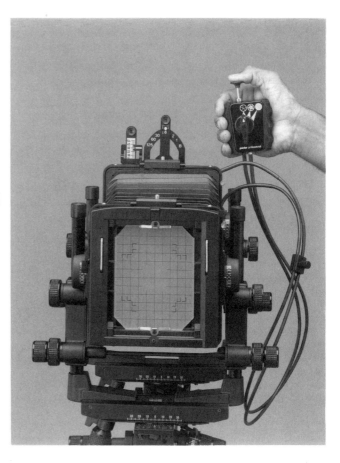

*Behind-the-camera controls allow you to continuously monitor the subject while making all shutter/aperture adjustments, which isn't possible otherwise.*

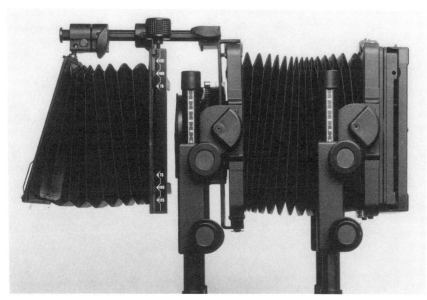

*To prevent stray light from striking the lens and creating flare, which degrades image contrast, a compendium bellows is a must.*

*Using this sheet-metal frame is a convenient way to handle and position fragile gelatin filters.*

## Camera Cases

A good, sturdy case is an absolute must, and there are many excellent models from which to choose. Your camera case should have fitted compartments for each camera component as well as space for a number of cut-film holders, extra lenses, and many of the other accessories that make up the view-camera system. When you are on location, the case serves as a work center, and in emergencies it should be sturdy enough to stand on if you must raise the camera so high that you can no longer see the groundglass. The two styles shown have advantages and disadvantages. The standard case allows you to store your camera completely set up and ready to go. It has considerable extra space for ancillary equipment; however, it is heavy and extremely bulky. The suitcase model makes the equipment more accessible and easier to handle. The drawback here is that the camera must be partially disassembled before it can be stored. Its greatest advantage is that it allows the camera to be kept with you when traveling, whereas the larger case must often be checked through to your final destination.

## Studio Stands

For use in the studio, these heavy-duty monopod stands have great stability as well as mobility because of their locking casters, size, and weight. The side arm that holds the camera can be lowered almost to floor level, or it can be elevated completely to the top of the stand for high-angle shooting.

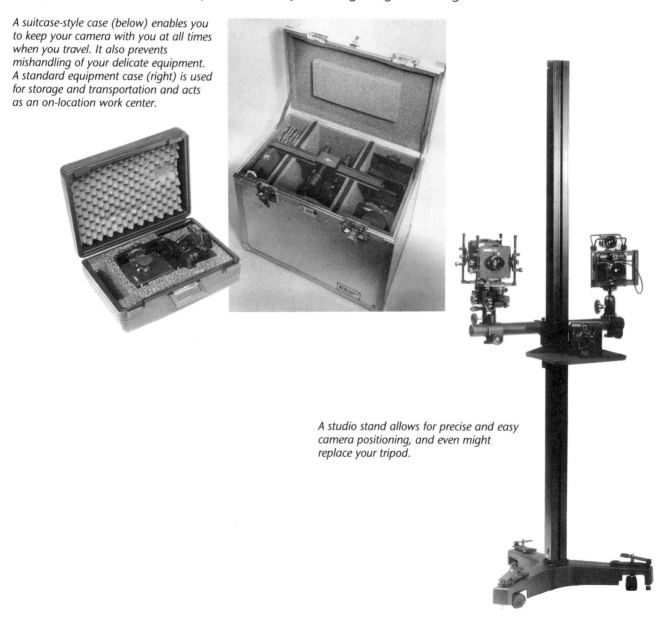

*A suitcase-style case (below) enables you to keep your camera with you at all times when you travel. It also prevents mishandling of your delicate equipment. A standard equipment case (right) is used for storage and transportation and acts as an on-location work center.*

*A studio stand allows for precise and easy camera positioning, and even might replace your tripod.*

*Chapter Two*

# LENSES, SHUTTERS, AND DIAPHRAGMS

Lenses, shutters, and diaphragms are the heart of every camera system; they are the components that direct and control the light to record an image on the film. The function of a *lens* is to take the large number of light rays reflected from any one point on the subject and reconverge them so that they meet at a single point exactly on the film plane. The result is a sharp image. This one plane of the subject that is in sharp focus on the film is called the *subject plane* or the *plane of sharp focus*. The *shutter* is a mechanical curtain that opens and closes to control the amount of time that the light is permitted to pass through the lens. The *diaphragm*, located between the front and rear elements of the lens, is an iris-like opening whose size can be adjusted to control how much light passes through the lens when the shutter is open. Together, the shutter and diaphragm are the controls that regulate how much light reaches the film.

## LENSES AND LIGHT TRANSMISSION

Light travels in straight lines. However, when light passes through a piece of glass at an angle, it will change direction. This change in direction, called *refraction*, occurs because light travels more slowly through glass than through air. If the glass is flat on both sides, the direction of the light rays will change again when they emerge from the glass so their path will be parallel to their original path before they entered the glass. If the glass is shaped like a prism, however, the light rays will be bent in the opposite direction to the angle at which they initially entered the glass.

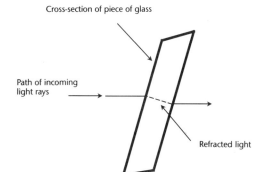

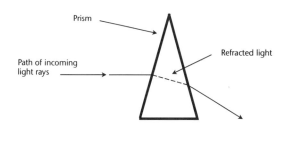

When light enters a flat piece of glass at an angle, it turns so that its direction of travel is perpendicular to that surface. When the light emerges from the opposite side, it turns once again; as a result, its track is parallel to its original direction of travel.

When a light ray first passes into a prism, it turns so that it is perpendicular to the entering surface. When it emerges, however, it turns in the same direction so that it is no longer traveling on a path that is parallel to its original track.

If you took two prisms and glued their bottoms together, the light rays coming from the same source would pass through both sides at an angle, and because of the changed direction, at some point two light rays would cross. If you were to place a piece of film at that spot, a sharp image of that point on the subject would be recorded. This would be an example of a very elementary lens.

The problem with using two prisms is that they won't converge the light rays from different points on the subject plane onto the same film plane as the first spot. There is a solution, however; use a curved piece of glass instead of a prism in order to converge the light rays. This curved glass really functions as a continuous series of prisms, and each point of the curve bends the light rays at a slightly different angle. If the curves are just the right shape, all the light rays from one plane of the subject will converge exactly on the film plane.

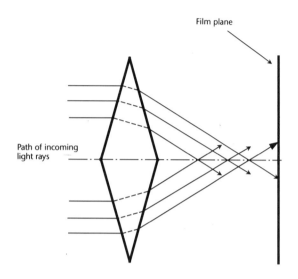

*When two prisms are assembled as shown here, light rays from the same source enter the prisms and bend back toward each other. However, the light rays all don't converge at the same point.*

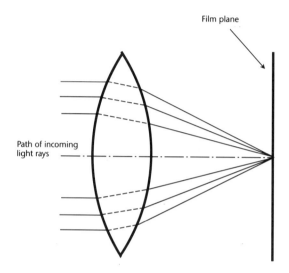

*A lens is used to converge light rays from a single point back onto a single point. A lens is simply a continuous series of prisms, each of which bends the light rays at a slightly different angle.*

# HOW LENSES WORK

The challenge lens designers face in creating different kinds of lenses is to work out the exact measurements for lens curvature, and select or design the proper types of glass for the different lens elements so that all of the light rays from the subject plane will converge on the film plane. This is a relatively simple problem if the subject is very small and directly in front of the lens. However, for those parts that are farther from the center of the subject, it becomes much more difficult. Adding to this difficulty is the fact that the outer edges of the film are much farther away from the lens than the center; therefore, light is not evenly transmitted throughout the film plane. The goal is to be able to take a three-dimensional subject out in front of the camera and have an image of it come out in perfect focus on the flat piece of film inside the camera.

It used to take lens designers months, and even years, to work out all the calculations needed to correctly shape the curvature of various lens elements that would produce a sharp image and eliminate the aberrations caused by the passage of light rays through curved pieces of glass. Today, however, those lens calculations can now be done by a computer in minutes. Designing a lens is no longer as time-consuming or labor-intensive. That is one reason lens manufacturers are continually coming out with new and improved lenses. Quality is now of such a high caliber that the difference in image resolution from one lens to the next is, at most, indistinguishable except under very tightly controlled test conditions.

All lens elements are shaped on sophisticated automatic machinery able to maintain a higher degree of accuracy than any artisan could ever hope to achieve. Lens mounts, lens barrels, and other metal and plastic parts are formed with great accuracy on automated machinery. Assembly and testing are also controlled by the most precise optical, electronic, and mechanical equipment.

So what is the difference between the high-priced lens made by one manufacturer and another brand's model selling for less? The answer lies in the number of inspections and the number of lenses accepted or rejected. The expensive lens will call for more quality control and closer adherence to design specification than the lower-cost one. This raises the price of the lens but for general use doesn't necessarily improve the quality of the image in the final photograph.

Much more important than the price or the brand name when you select a lens are the focal length, the angle of coverage, and the size of the maximum aperture. The focal length determines the size of the image on the groundglass from any given camera position. The angle of coverage determines just how large the image circle is as well as the range of camera movements that are possible with that particular lens. The maximum aperture determines the amount of light that can enter the camera at any given shutter speed. (Each of these features is discussed fully later in this chapter.)

# SHUTTER AND DIAPHRAGM CONTROLS

The *shutter/diaphragm combination* is the mechanism that controls the amount of light that enters the camera and strikes the film. It is a single unit mounted between the front and back elements of the lens. The shutter controls the length of time that the film is exposed. It is composed of a series of leaf-like blades, arranged in a circle, that open from the center for a specific time period and then close. The diaphragm is an adjustable iris that controls the size of the opening that the light passes through. Like the shutter, the diaphragm is made up of a series of blades that are preset at a specifically sized opening. Although there are numerous types of shutter/diaphragm combinations, the one generally used with view cameras is a single-unit mechanism that is mounted between the front and back elements of the lens.

There are advantages and disadvantages to this leaf-type shutter. The primary advantage is that flashbulbs or electronic flash can be synchronized to fire when the shutter is at its widest opening, regardless of the shutter speed. This enables you to control the amount of *ambient*, or existing, light entering the lens. In very bright scenes, this ambient light can affect the film by creating secondary, or ghosted, images. Another advantage of the leaf-type of shutter is that moving subjects record without their shape being distorted.

The leaf-type shutter's primary disadvantage is that high shutter speeds are generally not possible because of the large diameter of the lens opening. The shutter's leaves open and then reverse direction and close. It takes a certain amount of time for this to happen; the larger the diameter of the lens, the longer the process takes. For instance, an f/6.3 14¾-inch lens, for use on an 8 × 10 camera, has such a large diameter that its top shutter speed is only 1/50 sec. On the other hand, an f/8 65mm wide-angle lens for use on a 4 × 5 camera has an aperture small enough for the shutter to employ a top speed of 1/500 sec. This is the fastest shutter speed available with a mechanical leaf-type shutter. Shutter speed and aperture are directly related, as illustrated in the diagram on page 28.

*The shutter/diaphragm mechanism controls both the amount of light entering the camera and the length of exposure.*

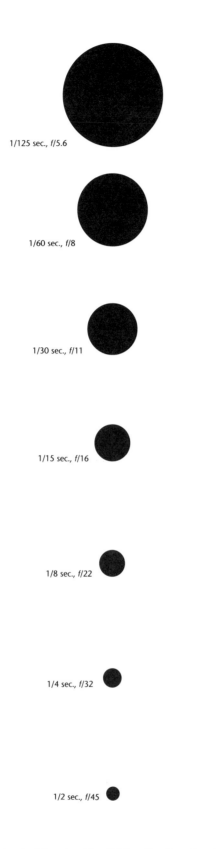

1/125 sec., f/5.6

1/60 sec., f/8

1/30 sec., f/11

1/15 sec., f/16

1/8 sec., f/22

1/4 sec., f/32

1/2 sec., f/45

*The f number is determined by dividing the diameter of the opening into the lens focal length. Each smaller f number is half the area of the preceding one. Therefore, it allows only half as much light to enter the camera.*

## Shutter Settings

Modern shutters have the following time sequence: T, B, 1, ½, ¼, ⅛, 1/15, 1/30, 1/60, 1/125, 1/250, and 1/500 sec. The "T" setting allows the shutter to be opened and to remain open until the shutter release is pressed a second time. With the "B" setting, the shutter remains open only as long as the release lever is depressed; once it is released, the shutter closes. The "1" denotes one second. The numbers that appear after "1" denote the fractions of a second. Older shutters have a slightly different speed sequence: T, B, 1, ½, ⅕, 1/10, 1/25, 1/50, 1/100, 1/200, and 1/400 sec.

Shutter speeds are controlled by a clock-type mechanism and are calibrated very accurately at specifically marked settings. *It isn't possible to use in-between shutter settings.* All shutter speeds are engraved on the shutter and are indicated by *detents*, or click stops, so you'll know when the shutter speed is properly set.

The diaphragm lever controls the size of the lens aperture. This lever also has detents for specific aperture settings; however, the diaphragm can also be set at intermediate settings that allow more precise control of the amount of light entering the camera. Aperture numbers are derived by dividing the diameter of the lens opening by the lens-to-film distance when the lens is focused at infinity. Thus, as the aperture opening gets smaller, the fractional numbers denoting the aperture become larger.

Just remember that each smaller opening admits half the amount of light of the previous larger opening. The aperture diagram opposite will help you see this relationship more clearly.

## Aperture Settings and Infinity

Aperture numbers are accurate only when the lens is focused at infinity. In photography, *infinity* is defined as a subject that is farther than 100 feet away from the camera. As you move the camera closer to the subject, the lens must be moved correspondingly farther from the film in order to focus the image; therefore, the aperture numbers become less accurate because there is less light striking the film (see the Rule of the Inverse Square on page 128).

The lens-to-subject distance is critical. When the lens is closer than eight times its focal length to the subject, it is so far away from the film that the aperture numbers are no longer accurate enough to give a reasonably correct exposure, and it is

necessary to recalculate the exposure. This increase in lens-to-film distance is called *the bellows factor* (see page 128 for more information).

There are several other controls on the shutter/diaphragm mechanism. The *press-focus lever*, which opens the shutter so that you can focus and compose on the groundglass, permits you to keep the shutter speed set for the correct exposure time instead of having to set it on "T" for a *time exposure* to keep the shutter open. There is an "X" setting for *flash synchronization* with electronic flash in newer shutters. Older shutters have both an "X" setting and an "M" setting for use with flashbulbs. A *cable-release socket* incorporated in the shutter release permits the shutter to be tripped without danger of moving the camera while making an exposure.

### Dual-Aperture Markings

Some older lenses are convertible. One element of these lenses can be removed and pictures made with the remaining element. Using a single element increases focal length, so it is necessary to have a second set of diaphragm markings to match this longer focal length. For instance, the 150mm *f*/4.8 Ilex Acuton lens that was used to

shoot the illustrations in this book has aperture settings from *f*/4.8 to *f*/45. With one element removed, its focal length is 247mm and the aperture settings run from *f*/10 to *f*/45.

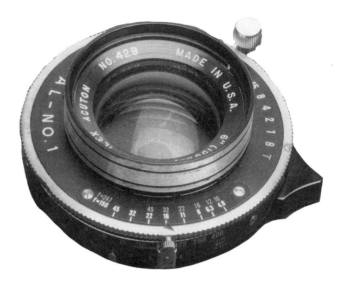

*Dual-aperture markings are included on some older convertible lenses that can be used at two different focal lengths. This 150mm f/4.8 Ilex Acuton lens has dual apertures ranging from f/4.8 to f/45.*

# LENS TYPES AND FOCAL LENGTH

A lens' *focal length* is the distance between the rear optical center of the lens and the film plane when the lens is focused at infinity. At infinity, the lens is as close to the film as it can possibly be and still focus a sharp image. So when the lens is focused on a distant object, it is closest to the film. To focus the lens on a closer subject, you must move the lens farther away from the film. Focal length is a fixed characteristic of the lens that is determined by the lens designer and generally can't be changed. The focal length is usually engraved on the front of the lens. You should have a variety of focal-length lenses so that you can shoot a wide range of subjects and photographic situations.

It is important to choose a lens according to the subject matter you photograph; knowing the various types of lenses available and how they affect image size and angle of view will ensure

that your photographs will appear the way you intended. *Image size* is determined by the lens' focal length. From any single camera position, the longer the focal length, the larger the subject will be in the picture. Conversely, the shorter the focal length, the smaller the subject will be. There is a direct mathematical relationship between lens focal length and image size. From the same camera position, if you switch to a lens with double the focal length of the original lens, the image size will be twice as large. On the other hand, if you put a lens with half the focal length on the camera, the image size will be half as large. The *angle of view* is the angle formed when lines are drawn from the diagonal corners of the film through the center of the lens. (This is discussed more fully on page 40.) The following is a list of the different lenses available and how they affect image size.

## Normal Lenses

For any camera, the normal lens has a focal length equal to the diagonal of the film. So for 4 × 5 film, the normal lens will be 6 inches. This is the length of the diagonal of the usable part of the film; it is slightly smaller than 4 × 5 because of the borders. A normal lens has an angle of view of between 50 and 55 degrees, depending on the film format. For a 4 × 5 camera, the angle of view is 53 degrees.

A normal lens shows the subject much the way the human eye sees it; *perspective*, or size relationships of the different parts of the subject, is approximately the way you would expect it to be if you were standing at the camera position. As a result, you can make sound judgments of about how large a particular object is and where it is located in relation to other objects in the picture. In other words, you have a reasonably accurate three-dimensional image of the subject. Keep this in mind when you determine both the camera position and the lens to be used.

## Long-Focus Lenses

A lens that has a focal length greater than that of the normal lens is considered a long-focus lens. These lenses have an angle of view of less than 53 degrees. This means that a long lens will record less of a subject than a normal lens would from the same camera position, and that the part of the subject that it does record will be larger than it would be with the normal lens.

Because the focal length of long lenses is longer than the diagonal of the film, in order to get the same coverage of the subject you must move the camera farther away from the subject. This ability to "reach out" can be an enormous advantage because it allows you to record subjects that you usually can't get close enough to with a normal focal-length lens to make a useful image. In closeup work and photomacrography, a long lens makes it possible to keep the camera far enough from the subject for you to operate the camera controls or to change lighting and recompose with ease.

*A normal lens has a focal length that is equal to the diagonal measurement of the film when the lens is focused at infinity. For a 4 × 5 camera, the length of the diagonal of the usable part of the film is 6 inches. This forms an angle of view of approximately 53 degrees.*

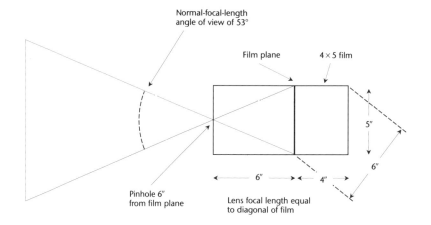

*The angle of view of a long-focus or telephoto lens is narrower than that of a normal lens. So for a 4 × 5 camera, a lens with double the normal focal length (12 inches) has an angle of view of 26½ degrees, or half the normal angle of view.*

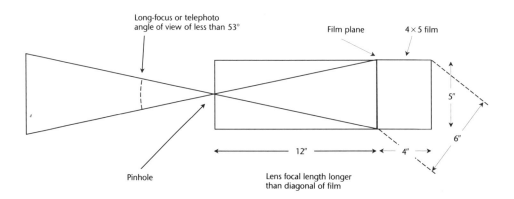

There are also disadvantages to having the camera farther away than normal from the subject. Even with moderately long lenses on a 4×5 or 8×10 camera, shooting down on your subject can become an acute problem if your tripod isn't tall enough or the studio ceiling isn't high enough to give you the coverage you need. You might have to compromise by using a shorter focal-length lens, by moving closer to your subject, or by using a smaller format.

Another by-product of working with a long lens is the *telephoto effect*; this is the creation of a flattened perspective in the image, resulting from moving the camera farther away from the subject. In many cases, this exaggeration is advantageous because it creates visual effects that you are seldom aware of—unless you look at the world through a tube with a very narrow angle of view. Photographs in which a huge sun descends behind a familiar object, such as a boat, are made with an extremely long lens at a great distance from the foreground subject. The resulting compression of the space between the sun and the object exaggerates the difference between their relative sizes.

This flattened perspective is commonly used in portraiture. It is standard procedure to select a lens of approximately double the normal focal length because this gives a negative-filling image without the camera being right on top of the subject. With a normal lens, the camera must be so close to the subject in order to fill the negative that the subject is distorted; as shown in the illustration below, the subject's nose appears much larger than it actually is.

At close distances, long focal-length lenses have an extremely shallow depth of field. This isn't a problem if you want to use sharp focus to selectively isolate a single part of the subject from an out-of-focus background. But limited depth of field does pose problems when you want more of the whole image in focus, such as in a double portrait where one person is posed slightly behind the other.

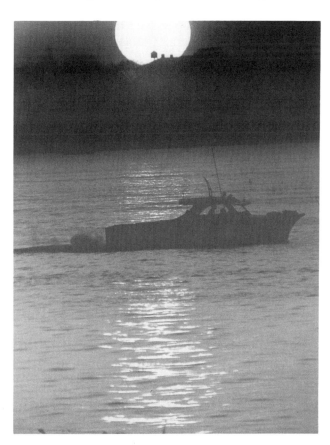

The sun in this photograph appears to be directly behind the boat. This flattened perspective is an example of the telephoto effect.

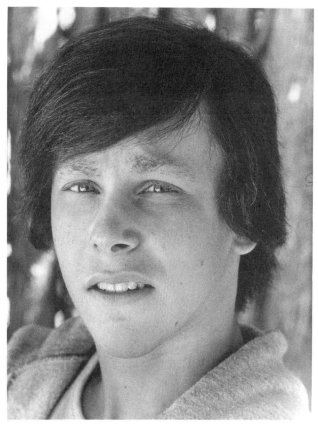

Using a view camera to shoot portraits results in the distortion of a flattened perspective.

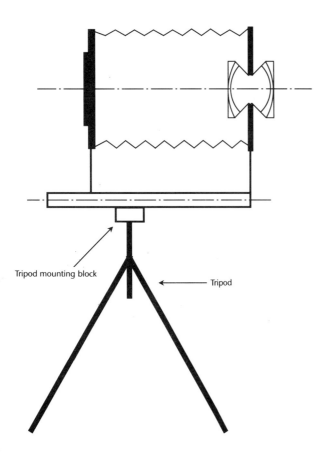

Tripod mounting block

Tripod

*For greatest stability, the weight of the camera should be balanced and centered over the tripod. Moving the lens or the camera back away from this balanced condition makes the setup unstable. This increases the danger of the camera either slipping out of position or vibrating during the exposure.*

Most longer lenses have small maximum apertures; they aren't high-speed optics. An *f*/4.5 lens is considered a fast lens; an *f*/5.6 or *f*/8 is closer to the norm with long focal-length lenses. In situations where there is abundant light, there is no problem, but under low-light conditions, longer lenses make focusing an image on the groundglass a more difficult process.

Long lenses require longer exposure times. To get the greatest depth of field and the most optical quality out of longer lenses, you generally use smaller apertures. This means correspondingly longer exposure times and, unfortunately, the risk of unsharp images because of vibration or camera movement. Most cameras are mounted on a tripod by a single screw located approximately under the center of gravity. This balances the entire unit. When a long lens is put on the front of the camera, it is necessary to move the lens farther away from the film. This moves the center of gravity forward on the tripod screw. The result is that the added weight at the front of the camera tends to pull the front downward, causing the entire camera/tripod combination to become unstable. It also puts tension on the tripod's tilt mechanism, which may either cause it to move or make it difficult to position the camera accurately.

All of these potential problems contribute to a less stable camera setup. While it is possible with most view cameras to shift the tripod mounting socket over the center of gravity, many photographers neglect to do this. In any case, the increased length makes it more likely that the camera will move during the exposure.

### Telephoto Lenses

These lenses are shorter than their indicated focal length. A standard long-focus lens is as long as its indicated focal length; if it has a 10-inch focal length, its rear optical center will be 10 inches from the film when it is focused at infinity.

Most lenses have two optical centers: one for the group of lens elements mounted in front of the shutter and diaphragm, and the other behind it. A 10-inch telephoto lens will record exactly the same image size and the same angle of view as the long-focus lens, but physically it will be shorter and less cumbersome than a longer lens of equal focal length. Generally, such lenses are used on smaller, handheld roll-film cameras rather than on view cameras.

## Wide-Angle Lenses

The focal length of these lenses is shorter than the diagonal of the film. A wide-angle lens has a much greater angle of view than a normal lens. One of the more interesting aspects of wide-angle lenses is a result of their extreme angle of view. With such a lens (and particularly when photographing vertical subjects), you can be looking straight down at your feet, but at the top of the picture you can be looking horizontally at the subject. In other words, you're literally looking at the subject from two directions at once. Linear distortion is also a problem with extreme wide angles. Parallel lines appear to converge at a distant point when observed or photographed. With wide-angle lenses, this convergence becomes excessive, causing a disturbing visual effect and making it difficult to visualize how the subject actually looks. When you photograph non-linear subjects, such as people, the resulting distortion can produce large, misshapen heads or make other parts of the body appear wildly out of proportion.

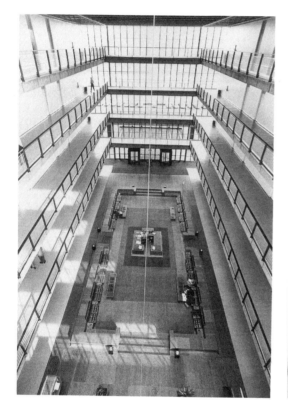

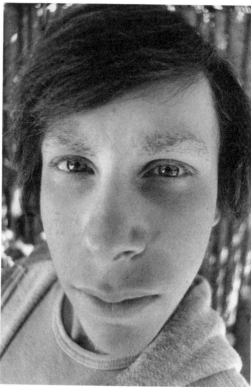

*A wide-angle lens caused parallel lines to converge excessively in the overhead perspective of Bell Laboratories, shown on the far left. When shooting portraits, use a lens of approximately double the normal focal length to avoid the unflattering distortion seen in the picture on the left.*

*A wide-angle lens with a focal length of 3 inches, which is half the normal focal length for a 4 × 5 camera, has twice as wide an angle of view as a normal lens. As such, the angle of view is 106 degrees.*

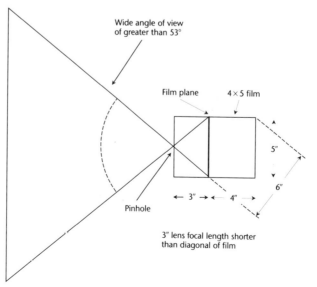

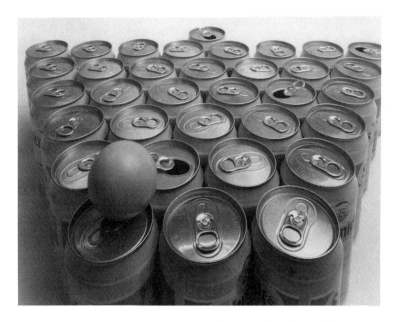

*Spherical objects appear distorted when photographed with wide-angle lenses. This distortion becomes more noticeable the farther the subject is from the center of the image and is most evident at the corners, as seen in this picture of cans and a baseball.*

Because of the short focal length of wide-angle lenses, it is often necessary for you to get extremely close to your subject to obtain the proper foreground image size. As a result, perspective exaggeration occurs. The back part of the subject appears to be much farther away from the front than it actually is, and the shapes of spherical objects in the photograph become highly distorted. When spheres are located away from the center of the picture, they distort to an oval shape tipped at an angle. This type of distortion becomes more apparent the farther the subject is from the center of the picture and is most apparent in the corners.

Also, because wide-angle lenses have such short focal lengths, they must be positioned relatively close to the groundglass when focused at infinity. The combination of back standard, bellows, and front standard makes it difficult to get the lens close enough to the groundglass to focus properly; there is too much camera in the way, particularly if you want to use the various swings and tilts. To overcome this problem, users of cameras with interchangeable bellows substitute a bag-like wide-angle bellows for the normal accordion-type bellows.

On cameras with non-interchangeable bellows, or when you work with extremely short focal-length lenses, it is often necessary to use a recessed lensboard to hold the lens and shutter/diaphragm mechanism. With a recessed board, camera controls may be difficult to reach. If the diaphragm and shutter controls are on the side of the lens rather than on the front, they can be impossible to read; however, if they have click stops, you can memorize these and work blind. I carry a dentist's mirror that I slip into the small space between the side of the lensboard and the shutter to read the settings. An alternate technique is to glue Mylar mirrors to the inner walls of the recessed lensboard.

## Wide-Field Lenses

This type of lens projects an image circle that is larger than the diagonal of the film. Don't confuse it with a wide-angle lens that has a shorter-than-normal focal length. A wide-field lens is a lens of normal focal length for its film size and has a very wide angle of coverage. Wide-field lenses generally have an angle of coverage of 70 degrees or more, compared to the 53-degree angle of view of a normal lens.

The rule of thumb when selecting a wide-field lens is that it should project an image circle large enough to cover the next larger film size than the one you're using. For instance, a wide-field lens of 6 inches in focal length and a 70-degree angle of coverage will project an image circle that is approximately 8½ inches in diameter. A piece of 5 × 7 film will just fit into that 8½-inch image circle. This means that the wide-field lens for the 4 × 5 film size could be used as a wide-angle lens for the 5 × 7 film size, although the image circle wouldn't be large enough to allow you to use the swings and tilts. The normal focal length for the 5 × 7 film size is 8½ inches.

### Flat-Field Lenses

These high-magnification lenses are designed specifically for photographing such flat subjects as documents or paintings and for closeup work. A flat-field lens produces excellent image quality even at 1:1 (life-size).

### Apochromatic Lenses

These lenses are highly corrected for accuracy of color and flatness of field. Apochromatic lenses are used primarily in graphic-arts work where flat subjects, high resolution, and maximum color correction are important. Studio photographers often use such lenses when the subjects that they're shooting are detailed and the final image quality is of critical importance.

### Soft-Focus Lenses

These lenses are designed specifically to create soft images. The degree of softness is controllable, and for this reason these lenses are often used in portraiture and fashion photography.

# BUYING A LENS

If you read the extensive literature of the lens manufacturers, you are likely to end up completely confused about which lenses to buy. There are a number of manufacturers, each with a wide selection of lenses and each of these with a staggering series of specifications. What do all those numbers mean?

The lens specifications supply useful information about focal length, type of shutter/diaphragm mechanism, maximum and minimum aperture, angle of view, diameter of the image circle, filter size, shutter speeds, and format size. Much of the rest of the spec sheet is an advertising copywriter's flight of fancy. I have found that one brand of lens will produce just as good an image as the next, despite all the touted advantages of this lens or that lens. Most important are your technical criteria for selecting a lens. The following is an overview of what you should consider before you buy a lens.

### Focal Length

For most photographers, focal length is the most important consideration when buying a lens. A primary, general-purpose lens is of normal focal length, which means that the focal length is equal to the diagonal of the film. Although this is basically true, there is often considerable variation in the actual selection of focal length, depending on the particular type of photography that is being done.

A photographer working with a 4 × 5 press or technical camera would want a slightly shorter focal length, such as 135mm (approximately 5½ inches) or 150mm (6 inches), because these lengths offer a shorter lens-to-subject distance in what are often close quarters. Studio photographers might select a focal length between 165mm and 210mm (between 6½ and 8¼ inches) for a general working lens because these focal lengths allow them to get the camera a little bit farther from the subject so that they can have easy access to it when doing setups and tabletop work. On the other hand, portrait photographers might very well use a basic lens as long as 300mm (12 inches) or longer in order to capture a large-size head on the film without the distortion introduced when the camera is moved close to the subject.

Few photographers are able to function for long with a single lens. For example, a wide-angle lens has a much greater angle of view than the normal lens. The primary wide-angle lens for a 4 × 5 camera is a 90mm lens, which gives an angle of view of about 80 degrees.

For longer focal lengths, you'll probably want either a 240mm or even a 300mm lens, depending on the focal length you select as your basic working lens. If you select a 150mm or 165mm lens as your normal working lens, then a 240mm lens will probably be your selection. On the other hand, if you choose a 210mm lens as your normal working lens, then a 300mm or 310mm lens will probably be what you want. When buying an additional lens, you will find that it is important to choose one that will give you a significantly different image size from the one you already have. If a 210mm lens is your basic working optic, then a 240mm lens wouldn't produce a significant enough change in image size to warrant the expense of purchasing it, at least in the early stage of your career.

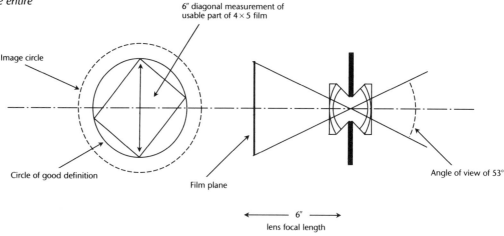

*A lens projects a circular image that must be as large as or larger in diameter than the diagonal measurement of the film in use. If it isn't, the image won't cover the entire piece of film.*

6" diagonal measurement of usable part of 4 × 5 film

Image circle

Circle of good definition

Film plane

Angle of view of 53°

6"
lens focal length

Lens focused at infinity

## Image Circle

The second most important consideration when buying a lens is the size of the *image circle,* also called the *circle of illumination.* The image projected by a lens is circular in shape; film, on the other hand, is rectangular. In order for you to obtain a usable picture, your film size must be small enough to fit within the sharpest area of the image circle. Therefore, the minimum diameter of the sharp part of the circle must be equal to the diagonal of the film. With such a lens, however, use of either the lens or the back slides, swings, or tilts will move part of the film outside the image circle and no image will be recorded on that part of the film. Make sure that the lens you buy has an image-circle diameter larger than the diagonal of the film.

## Maximum Aperture and Lens Speed

The maximum-aperture specification is indicated directly on the lens mount. Maximum aperture is calculated by dividing the diameter of the lens opening by the lens-to-film distance when the lens is focused at infinity. For example, if the diameter of the opening of a 6-inch normal focal-length lens is 1½ inches, the maximum aperture would be *f*/4.

For most roll-film cameras, a large aperture is important because fast shutter speeds are primary considerations—the faster the lens, the less exposure time is needed. This frees you to handhold the camera when you shoot, select higher shutter speeds, or use slower, fine-grain films. Aperture selection for a view camera, however, must be approached from a totally different point of view. After all, view cameras are mounted on tripods, and generally speaking, short exposure times are not as important as they are with handheld cameras. In fact, view-camera photographs are seldom exposed at the lens' maximum aperture.

So why would you need a fast lens? Because the wider the aperture, the easier it is to view the image clearly on the groundglass and the more accurately you can compose and get it in sharp focus. There is a tradeoff, however, that has to do with money. For instance, a major manufacturer of lenses for the view camera sells two different 90mm lenses: an *f*/8 lens selling for $569.95, and an *f*/5.6 lens selling for $1019.95. Is a one-stop difference in maximum aperture worth $450.00 to you? Most people will almost automatically say no. But having that one stop means twice as much light reaching the groundglass, thereby facilitating focusing. That might just make the difference between getting a critically sharp image and a not-quite-sharp image in a low-light situation. If you do all your shooting in a studio under controlled lighting conditions, the slower lens will work just fine. On the other hand, if most of your shooting is done on location in coal mines at midnight, the extra stop could make all the difference.

Something else to consider is that lenses are seldom at their sharpest when used at their maximum aperture. Generally, a lens will produce its sharpest image when it is stopped down two or three *f*-stops from its maximum aperture. After that, the image starts to lose a certain amount of sharpness because of diffraction.

As a matter of fact, lens manufacturers quote the angle of coverage and other technical lens specifications at the relatively small aperture of *f*/22 rather than at wide open. The reason is simple. The smaller the aperture, the greater the size of the circle of good definition. Additionally, stopping the lens down cuts out the use of the outer parts of the glass and therefore eliminates much of the area where the lens aberrations are most likely to be formed. For this same reason, a lens that might not have a sufficient angle of coverage at its widest aperture could very well cover the film adequately when stopped down.

# LENS DISTORTION

Perhaps the most misunderstood aspects of lenses are their distortions and aberrations. These simply refer to the inability of the lens to accurately reproduce the colors and shapes of the original subject. From a practical standpoint, there are only two lens defects that might affect your lens-purchase decisions: *barrel distortion* and *pincushion distortion*. These two terms indicate the relative inability of a lens to reproduce straight lines accurately.

Barrel distortion, or the excessive bending outward of the marginal light rays coming from a subject, is caused by uneven magnification in the lens. As a result, any straight lines along the edges of the subject bow outward and form a barrel-shaped image.

Pincushion distortion has just the opposite effect; it is the result of insufficient bending of the marginal rays. This uneven magnification causes the image of straight lines at the outer edges of a subject to bulge inward from the center in a pincushion shape.

These effects are generally most noticeable in images made with simple lenses. Except for very extreme wide-angle lenses, all modern lenses have been designed to eliminate or at least greatly reduce these distortion effects.

All lens aberrations involve an inability to focus the image sharply onto the film plane. Despite manufacturers' claims about how much they have eliminated these image defects, they never tell you the size of them. For example, I once saw a series of photographs of these aberrations. The images were less than half an inch in size. The accompanying text explained that the photographs of the aberrations were made through a microscope at a 300X magnification.

From a practical standpoint, except in very specific applications, you don't have to be concerned about aberrations.

Another specification often used by manufacturers as a selling point is the lens' *resolving power*; this is calculated in lines per millimeter. Resolving power is measured by the lens' ability to sharply record a large number of lines engraved on a test chart, something similar to an optometrist's eye chart. Resolving power is an issue with only the most critical of subject matter; from a practical standpoint, however, I strongly suspect that it doesn't make a bit of difference when it comes to the business of making photographs, unless of course your business is one of making photographs of test charts. There certainly are areas of photography, particularly in graphic arts and scientific applications, where lines-per-millimeter resolving tests are important, but for most normal picture-taking you can forget them.

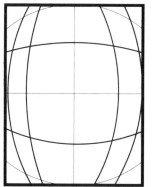
Barrel distortion

Pincushion distortion

*Both barrel and pincushion distortion are most apparent in simple lenses. Lens designers are able to correct these types of distortion by adding lens elements that have different curvatures and are made from different types of glass.*

# Chapter Three
# OPTICAL PRINCIPLES

Optics is the science of lenses and light. You see and make photographs by recording the amount of light that each subject reflects. This light travels in straight lines away from the light source, strikes the subject, and is then reflected back either into your eyes or into the lens of your camera. Next, the light is refracted by the lens elements and focused in order to form a sharp image. But the actual image that is recorded on film will be determined by a number of variables. These are exposure settings, angle of view, depth of field, lens-to-subject distance, lens-to-film distance, and image size. This chapter explains these optical principles and explores both how light is manipulated by the lens and how the image is recorded on the film.

## THE BASICS OF LIGHT AND EXPOSURE

To understand how light and lenses work together to form an image, consider the mechanics of a simple pinhole camera. Although images made with this type of camera can't match those made with a high-quality lens, thinking about images exposed through a pinhole will help you better understand the way images are made with a lens. A pinhole camera is nothing more than a light-tight box with a means of holding a piece of film on one end and a pinhole-sized opening in the other. This pinhole is the aperture through which light enters; the length of time that the light is permitted to enter is controlled by covering and uncovering the pinhole aperture.

When light strikes a subject, it is reflected in all directions from each single point on the subject. A very few of these light rays pass through the pinhole and strike the film. Light rays reflecting from every other point on the subject also pass through the pinhole, thereby forming an image of the subject on the film. If the hole is small enough, only a tiny spot of light reflecting from each point on the subject strikes the film and a reasonably sharp image of the subject will be produced. If the hole is larger, rather than a tiny spot being exposed on the film, a much larger area will be affected. The result is a less sharp image. The larger the hole, the less well-defined the image will be.

If you want to experiment, you can make a simple pinhole camera easily using a 4 × 5 view camera. Substitute a thin piece of metal, such as a small piece of aluminum cut from the bottom of a pie plate, for the lens. Punch a hole in the center of the metal with a #10 needle. To make a clean hole, back up the aluminum with cardboard. This size needle will make an opening equal to approximately f/346 when the pinhole is positioned 6 inches away from the film (see page 28 for an explanation of how the aperture is calculated). Make a flap of black cardboard to serve as a shutter. Unscrew the lens from the view camera's lensboard and tape the pinhole in place with black masking tape for a light-tight fit.

You can calculate the exposure for the pinhole using an ordinary exposure meter, although few meters will give exposure times for an aperture of f/346. The following is a progressive list of whole apertures: f/8, f/11, f/16, f/22, f/32, f/45, f/64, f/90, f/128, f/180, f/256, f/360, and f/512. The technique is to take a meter reading of the scene that you want to photograph. By using that reading, you can calculate how much additional exposure time is needed in order to expose the film at f/346. Remember, for each higher f number, you must double the exposure time because the size of the opening is only half as large as the preceding one. You'll have to experiment with the exposure time because the pinhole size won't be completely accurate. With ISO 400 film, an exposure-meter reading in bright sunlight will call for an exposure of f/16 at 1/500 sec.; at f/360, the correct exposure time will be 1 sec. For instant results, try making the pictures on Polaroid film.

In one way, the images made with a pinhole camera are unique. Everything in the pictures is equally sharp because each spot of the subject reflects a tiny bundle of rays that pass through the pinhole in a straight line and strike only one small spot on the film. In effect, pinhole pictures have infinite depth of field. In contrast, lenses create a sharp image by converging a much larger number of light rays onto a single spot on the film. If these rays don't converge exactly on the film plane, the final result is an out-of-focus image (see page 43 for more information about depth of field).

A simple experiment with a pinhole camera will enable you to understand the connection between angle of view, camera position, and image size. This interrelationship is true for camera lenses as well as for the pinhole because it is a function of the focal length (which is the distance between the lens focused at infinity or the pinhole and the film) rather than whether a lens or a pinhole is being used.

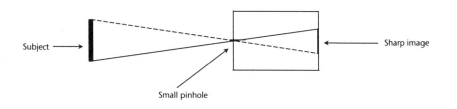

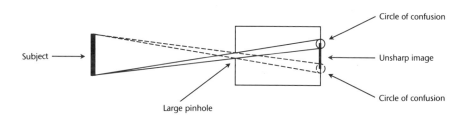

*A small pinhole allows very little light to strike the film, thereby requiring long exposure times. The opening, however, produces a reasonably sharp image, as seen on the left. Because the light isn't focused, as it would be with a lens, all parts of the subject are equally sharp. As shown below, a large pinhole allows a great deal of light to strike the film, which shortens exposure times. The problem is that a large number of light rays from each point on the subject pass through the opening and strike the film, so the image is unsharp.*

*A small pinhole renders a remarkably sharp image. The shot on the far left was made using a pinhole 0.018 inches in diameter. The less-sharp shot on the left was made with a larger pinhole, 0.384 inches in diameter.*

# ANGLE OF VIEW

The *angle of view* describes how much of the subject the camera will actually see from side to side and from top to bottom from any given position. This is controlled by how far the pinhole is from the film and the size of the film. A normal lens for a camera has a focal length approximately equal to the length of the diagonal of the film when the lens is focused at infinity.

To understand this concept better, first measure the diagonal of the film in the pinhole camera and then move the pinhole opening this same distance away from the film. If you then draw intersecting lines from each corner of the film, the angle these lines create will be approximately 53 degrees. With a $4 \times 5$ sheet of film, this diagonal line will be about 6 inches long, which is the focal length of a normal lens on a $4 \times 5$ camera. As discussed in the preceding chapter, the longer the focal length of the lens, the narrower the angle of view and the less of the subject that will be covered from side to side and top to bottom. The shorter the focal length of the lens, the wider the angle of view and the more of the subject that will be covered from side to side and from top to bottom. There is a direct mathematical relationship between focal length and how much of the subject is recorded. If you double the focal length, you will see only half as much of the subject from side to side and from top to bottom. Conversely, if you cut the focal length in half, you will see twice as much of the subject from side to side and from top to bottom.

## Wide-Angle Camera
If you leave the camera in the same position and bring the film closer to the pinhole, the picture will show more from side to side and from top to bottom of the scene. In other words, the angle of view is wider. If the film is moved until it is only half the distance from the pinhole, the angle of view will be approximately 106 degrees, which is twice as large as it is at 6 inches. Each object in the picture will be half as large, and you will be able to see twice as much of the subject from side to side and from top to bottom.

## Long-Focus Camera
If the pinhole is moved away from the film, the opposite effect will take place. The pinhole will see less of the subject. If this distance is doubled, the angle of view will be exactly half, or $26\frac{1}{2}$ degrees, and the size of each part of the subject will be twice as large. Also, you will be able to see only half as much of the subject from side to side and from top to bottom.

You will get exactly the same changes in angle of view if you exchange a lens with a 3-inch focal length for the 3-inch pinhole, or a lens with a 12-inch focal length for the 12-inch pinhole. The size of the image on the film will be the same for either the lens or the pinhole. The difference is that the image made with the lens will be sharper on the plane where the lens is focused, but will be less sharp in areas where the lens isn't in focus. The image made with the pinhole will be considerably less sharp overall, but all the parts of this image will be equally sharp. Finally, the exposure time for the lens will be considerably shorter because the lens opening is so much larger than the pinhole.

For all film sizes, a normal lens, or pinhole, has an angle of view of between 50 and 55 degrees, depending on the film format. Each sees the subject approximately the same way the human eye does in terms of side-to-side and top-to-bottom coverage of the subject.

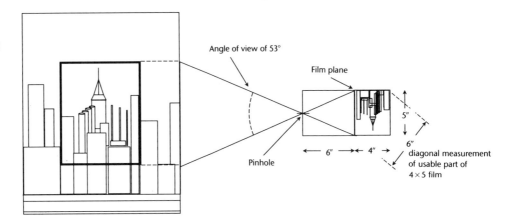

As the pinhole (or shorter focal length) gets closer to the film, it projects an image that sees more of the subject from side to side and from top to bottom than the normal lens does. There is a direct mathematical relationship between the angle of view and the distance of the pinhole or lens from the film. If the distance is cut in half, the angle of view is cut in half, too.

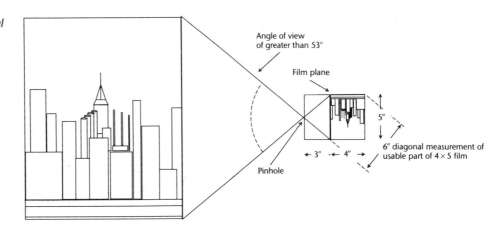

If the pinhole is moved away from the film or a longer lens is selected, the angle of view becomes narrower. This means that the image becomes larger but that less of the overall subject is visible.

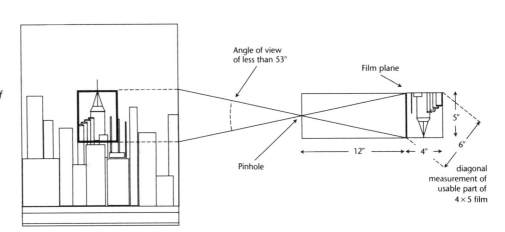

# ANGLE OF COVERAGE

An extremely important consideration in selecting a lens for use on a view camera is how large the image circle is that it projects in relation to the size of the film. This is referred to as the lens' *covering power*. Although the outer edges of the image circle are unsharp, the major portion is in sharp focus. This sharp segment is called the *circle of good definition*.

The *angle of coverage* is the angle formed by the outer edge of the image circle and the center of the lens when the lens is focused at infinity. Don't confuse this with the angle of view, which refers to the angle formed by the diagonal corners of the film and the lens when the lens is focused at infinity. The angle of coverage is important when you select a lens because the size of the image circle determines how far you can slide, swing, or tilt the lens before the image goes out of the area of sharp focus.

All lenses of the same focal length don't have the same covering power. For example, a 90mm lens for a 35mm camera projects an image circle with a diameter equal to the diagonal of the 35mm frame, which is approximately 43mm or 1¾ inches. If this lens were put on a 4×5 view camera, it would record a circular image 1¾ inches in diameter on the film and the rest of the film would be blank. The size of the subject, however, would be exactly the same as when photographed with the 90mm lens designed for a 4×5 camera. The difference is that with the lens designed to cover the 4×5 film, more of the subject from side to side and from top to bottom is recorded. The lens designed for use on a 4×5 camera has greater covering power than the lens for the 35mm camera.

*Covering power refers to the size of the image circle projected by the lens. It determines how far you can move the film away from the lens' optical center and still get an image on it. The greater the covering power of the lens, the farther you can displace the image and therefore the greater the control you have over the plane of sharp focus as well as the shape of the subject or its position on the groundglass.*

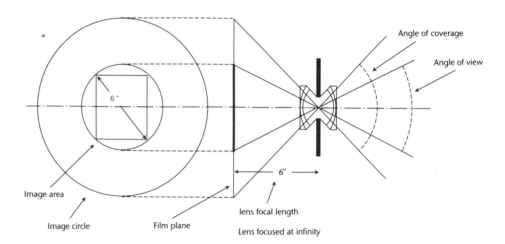

Angle of coverage

Angle of view

6 "

Image area

Image circle

Film plane

lens focal length

6"

Lens focused at infinity

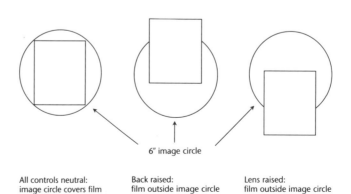

6" image circle

All controls neutral:
image circle covers film

Back raised:
film outside image circle

Lens raised:
film outside image circle

# DEPTH OF FIELD

In discussing the pinhole, I explained that the light that is reflected from any point on the subject spreads out in all directions; however, only a small bundle of these light rays passes through the pinhole. Each individual point on the subject is recorded on the film as a tiny point by the specific bundle of light rays coming directly from that point on the subject, passing through the pinhole, and striking the film. As a result, everything in the picture is equally sharp.

On the other hand, when a photograph is made with a lens, a much larger bundle of light rays from each point passes through the opening. In order for you to get a sharp image, these light rays must be reconverged so that they meet at the film plane. To do this, the lens must be placed at a specific distance from the film. When the lens is in the appropriate position, a single plane of the subject will be in sharp focus. Consequently, every part of the subject that isn't on this plane is less sharp. The zone in front of and behind this plane of the subject that is still acceptably sharp is called the *depth of field*. Depth of field is a variable that is controlled by three factors: the size of the lens' aperture, the lens-to-subject distance, and the lens' focal length.

## Aperture and Depth of Field

There is a direct correlation between the aperture and depth of field. The wider the aperture, the shallower the depth of field. As the diaphragm is stopped down, depth of field increases. This increase is greater behind the plane of sharp focus than in front of it. In general, the zone of sharpness behind the subject plane will be approximately twice as great as that in front of the subject plane. At close camera distances and wide apertures, the depth of field is extremely shallow. If you simply stop the lens down, the depth of field will increase. But because this increases the area of sharpness both in front of and behind the plane on which the lens is focused, you might be increasing sharpness where there is no subject matter and, therefore, you're wasting some of the potential increase in the depth of field.

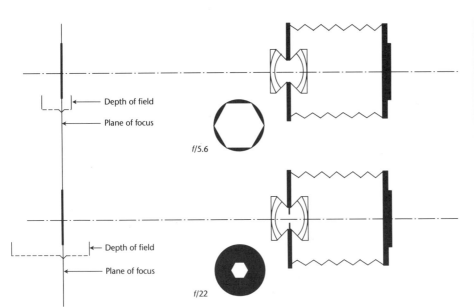

The primary means of controlling depth of field is the lens opening. As shown directly above, the smaller the opening, the greater the depth of field. This is directly observable on the camera groundglass and should be used as a way to ensure that there is sufficient depth of field when a picture is composed.

At close camera-to-subject distances and at wide apertures, depth of field is extremely shallow, as seen here.

To achieve maximum depth of field in any shooting situation, you should focus on a point approximately one-third of the way into the subject. Then as you stop down the lens, sharpness will increase in front of as well as behind this *plane of sharp focus* until you reach the lens' smallest aperture.

At this point, however, a problem might arise if neither the foreground nor the background is in sharp focus. In fact, the foreground and background may be so far apart that at the lens' minimum aperture, there still won't be adequate depth of field to cover both of them. The solution is to adjust the focus slightly so that the foreground part of the subject is in sharp focus — even though the background might become less sharp. The reason involves human vision. Objects that are close to you are sharper and can be seen in detail more easily than those that are at a greater distance. So by biasing the focus toward the foreground, you are reproducing, in effect, normal vision and are less likely to note that the background detail isn't as sharp as that of the foreground.

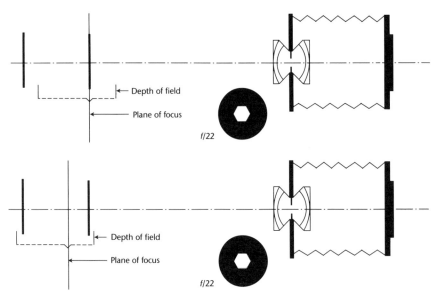

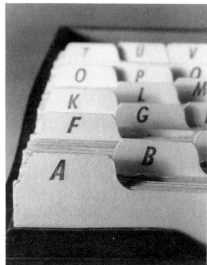

*As the illustration above shows, it is possible to position the area of sharp focus very precisely by adjusting the focus as you watch the image on the camera groundglass. The foreground part of the image should be the sharpest. To obtain maximum depth of field in the top shot, I first set the focus approximately one-third into the plane of subject "A". For the bottom shot, I stopped down the aperture to increase depth of field in front of and behind this plane, at "B".*

## Lens-to-Subject Distance and Depth of Field

In general, the larger the subject appears in the image, the shallower the depth of field. So the lens-to-subject distance is another factor that controls depth of field. The farther the camera is from the subject, the smaller the image and the greater the depth of field will be.

## Focal Length and Depth of Field

A lens' focal length is the third factor that determines in part an image's depth of field. From any given camera position, the depth of field at a given aperture will always be the same, regardless of the focal length of the lens, provided the image size is the same. This means that if you photograph the same scene from the same camera position at an aperture of f/11 with both a 6-inch lens and a 12-inch lens, and then enlarge the center section of the image made with the 6-inch lens so that it is the same size as the image made with the 12-inch lens, the depth of field will be the same in both images. If you move the camera twice as far away and shoot at the same aperture with the 12-inch lens, the resulting image size and depth of field will be the same as those of the 6-inch lens at the closer distance.

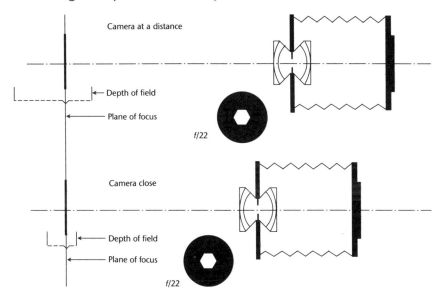

*The closer the camera is to the subject, the shallower the depth of field.*

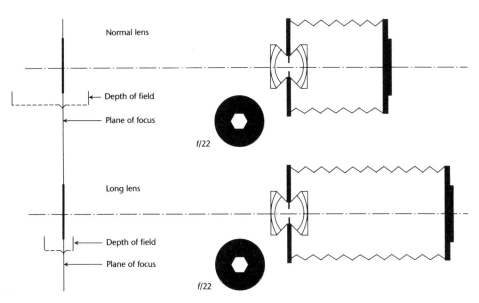

*To achieve extensive depth of field, select a lens with a short focal length; for a shallow depth of field, select a longer focal-length lens.*

## Circle of Confusion

A *circle of confusion* is an out-of-focus bundle of light rays that strikes the film. Depth of field is directly related to the size of the circle of confusion. If this circle is small enough, it will record on the film as a point and, therefore, that part of the image will appear to be in sharp focus. The light rays that reflect from any point on the subject plane radiate out in all directions. Because the lens is round, a circular bundle of these light rays passes through it. The lens reconverges these rays so that when the camera is in focus, they come together at a point on the film plane.

The light rays from any part of a subject that is in front of this plane of sharp focus—and, therefore, is closer to the camera—will converge at a point behind the film plane. Remember, the closer the subject is to the lens, the farther the lens must be from the film if the subject is going to be in sharp focus. Since the camera is already focused on the main subject plane, the light rays from the closer subject will meet behind the film plane. And, because they can't pass through the film plane, they record on the film as a disc of light rather than as a point of light. This circular area is the circle of confusion.

If, however, part of the subject is beyond the main subject plane and consequently farther away from the camera, the light rays from the subject will converge before they reach the film plane. Because there is nothing to stop them,

they simply cross each other and proceed until they, too, strike the film. Once again, the exposure on film is a disc of light instead of a single point of light. In summary, any object in front of or behind the plane of sharp focus will be out-of-focus. The farther away the object is from this plane, the more out-of-focus it will be and the larger the circles of confusion will be. These circles of confusion are most apparent when pictures are made with the lens at its widest opening and the camera is close to the subject.

Conversely, when the lens is stopped down, the sizes of the circles of light entering the camera are much smaller. If these discs of light on the film are small enough, they will appear as points rather than circles and that part of the picture will be sharp. As the lens is stopped down, the circles of confusion are smaller, the depth of field is greater, and the overall picture appears sharper. To appear as a point on the film, the circle of confusion must be less than $\frac{1}{1000}$ of the normal focal-length lens for any particular film size. For example, with a $4 \times 5$ piece of film, the circle would be .006 inches or smaller.

You might not understand why focusing can pose a problem. It might seem that all you have to do is to stop the lens down far enough so that all the circles of confusion are small enough to record as points of light, thereby ensuring that everything will be sharp. In addition, then, you might think that doing this will prevent you from

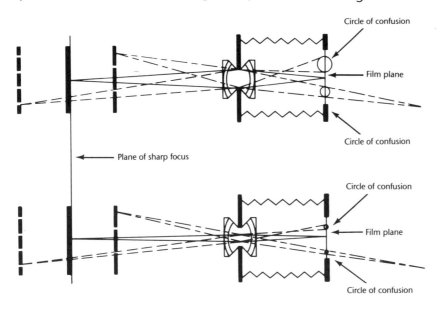

*Depth of field is determined by the size of the circle of confusion. If the circles are small enough, they appear as points and that part of the image is sharp. Circles of confusion appear as out-of-focus areas in the final image.*

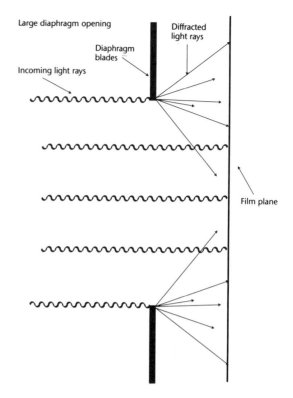

*This chart shows the maximum diameters of circles of confusion for various view-camera formats.*

using lens swings and tilts in order to get everything into sharp focus. This isn't completely true. First, reciprocity failure could lead to unacceptably long exposures and changes in colors (see page 130). The other factor is diffraction, a phenomenon that makes images taken at very small apertures unsharp (see below).

## Diffraction and Image Sharpness

When a light ray passes a sharp edge, it gets hooked on that edge and spreads out, much like a stream of water from a hose when it strikes a sharp edge. This spreading of light rays is called *diffraction*. It occurs when light rays pass the edge of the lens diaphragm.

If the diaphragm opening is fairly large, the amount of diffracted light is small compared to the total amount of light entering the camera; therefore, it has little effect on the image unless the camera is pointed directly at the light source. However, if a very small opening is being used, the amount of diffracted light can make up a large portion of the light entering the camera, and this will affect the image sharpness.

At any lens-to-film distance, there is a crossover point where, if the aperture becomes smaller, the increase in overall sharpness resulting from the increased depth of field will be cancelled by the decrease in sharpness resulting from diffraction. Most lenses deliver their best image quality when they are closed two or three stops from their maximum aperture because aberrations are usually caused by the outer part of the lens. At this point, most of the aberrations have been masked or eliminated because of the small size of the opening, and there is not enough diffraction present to degrade the image sharpness.

*As the lens opening gets larger, the amount of light that is diffracted becomes smaller and therefore affects image sharpness less.*

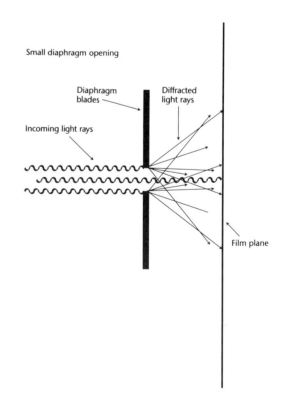

*At very small apertures, a large part of the light that passes through the lens opening is diffracted. Consequently, the images aren't as sharp as those taken at larger apertures.*

# PERSPECTIVE MANIPULATION

Selecting the appropriate focal-length lens for any shooting situation is an absolute must if you hope to create a particular visual effect. The correct lens needed for each picture is dictated by several interrelated factors: perspective, focal length, covering power, and angle of view. Most photographers, however, are under the mistaken impression that the way a subject looks is controlled by the focal length of the lens in use. They also speak of the wide-angle effect or the telephoto effect and assume that these are caused by a wide-angle lens or a telephoto lens, respectively. Nothing could be farther from the truth. A subject's appearance is determined by the position of the camera in relation to the subject. The lens' focal length determines only the angle of view.

When you photograph a three-dimensional scene, one that has height, width, and depth, it is recorded on a two-dimensional surface (film), one that has only height and width. When you look at a photograph, however, you notice the illusion of depth, the missing third dimension. This is called *perspective*.

The most important visual clues creating the sense of depth are the size differences among the various objects in a photograph. If you take two objects of similar sizes and position one near you and the other farther away, the closer object will look larger than the distant one. The size difference enables you to judge how far each object is from you, as well as how far apart the objects are from each other.

An interesting phenomenon takes place if you move either very close to the nearer object or farther away from it. The perspective, or three-dimensional effect, is exaggerated. But your mind tends to fool your eye about what the object actually looks like. Consequently, you make a subconscious adjustment so that it appears normal. It is only when you look at a photograph of the object that this apparent exaggeration becomes noticeable.

## Telephoto Effect

When you move the camera farther away from both objects, they get smaller on the groundglass. The one closer to you decreases in size much faster than the more distant one. This is because proportionally you're moving much farther away from the near object than you are from the far one. As a result, the difference in size of the two objects seems to be smaller. The result is that they appear to be closer together even though the distance between them hasn't changed. This compression of space is called the *telephoto effect*.

Photographers often mistakenly attribute this effect to the use of a long-focus or telephoto lens when shooting from a long distance. They don't realize that the effect is actually the result of a change in camera position and has nothing to do with the lens on the camera. A long-focus or telephoto lens simply enables them to get a large image of the more distant object.

## Wide-Angle Effect

When you move the camera closer to the objects, the opposite effect occurs. Both foreground and background objects get bigger as you move the camera closer to them. As a result, it is necessary to switch to a wide-angle lens in order to include everything in the picture. Because the camera is now proportionally much closer to the near object than to the far one, the more-distant object is now proportionally smaller than the foreground object and consequently appears farther away. This exaggeration of perspective is called the *wide-angle effect*.

Just as they do with the telephoto effect, many photographers erroneously make a connection between the lens on the camera and the look of the final picture. They think that the wide-angle lens is the reason for the wide-angle effect. What they don't realize is that they moved closer to the objects to be able to fill the frame because the wide-angle lens provides more coverage from side to side and from top to bottom. The movement of the camera, then, is the actual reason for the resulting wide-angle effect.

The photographs opposite illustrate these effects at different camera positions. In the shot on the bottom left, the camera was set up with a normal 150mm lens. The two plates were positioned so that the far plate was approximately half the size of the one in the foreground. From a lens-to-subject distance of 6 feet, the front plate measured 4 inches wide on the groundglass

while the far plate measured about 2 inches wide. For the shot on the bottom right, which was also taken with a 150mm lens, the camera was moved back until the front plate measured 2 inches wide on the groundglass. The camera was now approximately twice as far from the front

plate as it was in the preceding shot. The distance between the camera and the far plate wasn't doubled; the camera was moved just 50 percent farther away, so the far plate's size was reduced by only one-third. As a result, the plate measured 1⅓ inches wide on the groundglass.

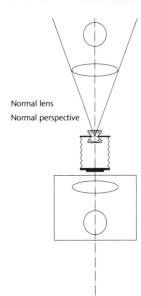

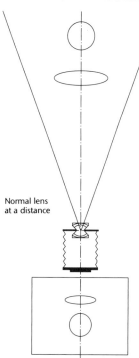

*With a normal lens on the camera, the angle of view is approximately the same as that of the photographer.*

Normal lens
Normal perspective

*When the camera is at a distance from the subject, both the foreground and background get smaller. Proportionally, however, the camera moves farther from the foreground than from the background so the foreground decreases in size more. Also, the background appears to be closer to the foreground than it was before, a result of the telephoto effect.*

Normal lens
at a distance

But there was a problem. Both images were now very small, so to increase their size, a 300mm lens was put on the camera. Because this focal length was double that of the normal 150mm lens, the size of the image on the groundglass was twice as large. (A similar change in image size took place with the pinhole camera when the distance between the subject and the pinhole was doubled from 6 inches to 12 inches.) The front plate once again measured 4 inches wide on the groundglass. The far plate also became twice as large, shown on the right; it measured 2⅔ inches in width on the groundglass whereas originally it was only 2 inches wide.

Because you judge the distances between objects by their size relationships, you might think that the more distant object is closer to the foreground than it was before—a result of its being larger now than it was. Remember, though, the camera position not the lens' focal length causes the telephoto effect. To prove that this change in perspective is the result of a shift in camera position, take a look at the shot below on the far left. When the camera was at a distance of 12 feet, a third photograph of the setup was made with a 75mm lens. The center section of this negative was enlarged to match the size of the image made with the 300mm lens from the same camera position (middle shot). Obviously, the foreground and background images and the depth of field are the same. The only difference is that the enlargement is grainier than the print made from the 300mm negative (far-right shot).

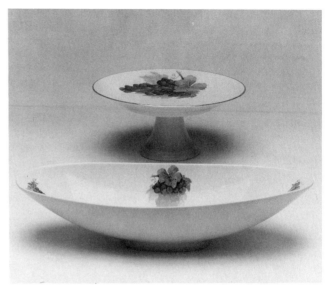

*Here, I positioned the camera at a distance from the subject and switched to a 300mm lens. Both parts of the subject doubled in size.*

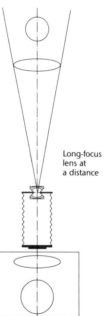

Long-focus lens at a distance

Going back to the original setup using the 150mm lens, consider what happens when the camera is moved forward so that it is 3 feet from the front object. Because the distance is cut in half, the foreground image is twice as large; it is now 8 inches wide. In fact, it is so large that only part of it is visible on the groundglass. On the other hand, the distance to the far object has been reduced by only about 25 percent. As a result, the size of the background image, rather than doubling, is increased by only 25 percent. It is now 2½ inches wide on the groundglass.

Because the image of the front plate is now too big to fit on 4 × 5 film, it is necessary to reduce the size of the image by changing lenses. To accomplish this, a 75mm wide-angle lens, whose focal length is half that of the 150mm lens, is placed on the camera. The 8-inch-wide foreground image is now reduced to half its size, or 4 inches. The 2½-inch-wide background image is also cut in half; it is now only 1¼ inches wide on the groundglass. Because of this camera movement, the distance between the two objects seems to be greater because the rear object is smaller than it was before. Remember: this wide-angle effect is the direct result of positioning the camera closer to the subjects, not the focal length of the lens in use.

Normal lens close

*When the camera is moved closer to the subject, the background becomes proportionally smaller on the groundglass. This prevents the entire subject from being recorded.*

Wide-angle lens close

*Here, I used a 75mm wide-angle lens to reduce the size of both objects; this makes the far plate appear to be farther away than the front plate because it is proportionally smaller.*

When selecting the proper lens to create a specific image perspective, you will find that it is important to incorporate camera position, focal length, and covering power correctly. Here are the basic procedures to follow when using these factors to manipulate perspective in the image:

1. *Camera Position.* Locate the camera at the distance from the subject that will give the desired size relationship between the foreground and background objects. For example, if you want the foreground objects to be large and the background objects to be smaller in order for them to appear far away, move the camera closer to the foreground objects. If, on the other hand, you want the foreground and background to look large or to appear to be very close together, set up the camera at a considerably greater distance from both groups of objects.

2. *Focal Length.* Select a lens focal length that will give you the top-to-bottom and side-to-side coverage that you need from the camera position that has been dictated by the required perspective. For example, if you must move the camera away from the subject to get the desired size relationship between the foreground and the background, everything will be smaller on the groundglass. Because the lens is farther away, it takes in more of the area to the sides and above and below the specific subject area than you want in the final picture. In order to get a large, negative-filling image of the subject, you will need a longer focal-length lens. This lens will cover only the part of the subject that is important and will eliminate all the extraneous matter on the top, sides, and bottom.

Another way to achieve the same effect is to shoot the picture from the pre-selected camera position using the normal lens and then enlarge just the central part of the negative to get the image size that you want. The drawbacks here, of course, are that enlarging a small segment of the negative degrades image sharpness and makes the film's grain structure more apparent. If you move the camera from its original position to a closer one in order to change the size relationship between the foreground and the background, everything on the groundglass will be larger and you will no longer get as much in on the sides or from top to bottom. The solution is to change to a shorter focal-length lens so that you will get the coverage you need from side to side and from top to bottom.

3. *Covering Power.* To utilize the camera's slides, swings, and tilts, select a lens that projects an image circle with a covering power greater than the diagonal of the film. Wide-field lenses are specifically designed for use on view cameras. Most have an angle of coverage of 72 degrees; the corresponding image circle is big enough to cover the next larger film size. Consider the following example. The length of the diagonal of the film used in 4 × 5 cameras is approximately 6 inches. If the sharp part of the image circle is only 6 inches in diameter, any movement of either the back or the lens will put part of the film outside the usable circle. In order for you to use any of the camera's movements for shape or depth control, you will need to select a lens that projects an image circle larger than 6 inches. A wide-field lens with a focal length of 6 inches and an angle of coverage of 72 degrees will project an image circle of approximately 8½ inches in diameter. This lens is considered adequate to handle all but the most extreme camera movements.

## Chapter Four

# THE CAMERA MOVEMENTS

A view camera is an extremely sophisticated photographic device that enables you to accurately control the shape of the image and to precisely place the plane of sharp focus. No guessing whatsoever is involved once you learn how to use a view camera. Many photographers think of a view camera as a big box camera because they don't realize the purpose of its movements or how it functions. To complicate the issue even further, the view-camera images they see are often the result of compound movements that leave them puzzled about what took place. To solve the mystery, it is important to understand that there are only four basic camera movements:

1. The lens can be pivoted around its optical center both vertically and horizontally.

2. The lens can be moved from side to side or up and down in relation to the film.

3. The back can be pivoted both vertically and horizontally.

4. The back can be moved from side to side or up and down in relation to the lens.

When you think about these movements, you will realize that if you swing or tilt the lens or the back, you're actually causing the same effect. The lens plane and the film plane are no longer parallel to each other. The only difference between a swing and a tilt is that the swing takes place in the horizontal plane while the tilt takes place in the vertical plane. If you slide, raise, or lower the lens or the back, you create an off-center relationship. The lens isn't directly in front of and centered on the film any more. So when you move either the lens or the back to control the shape or the area of sharp focus in one direction, you're distorting or throwing something else out of focus in another direction.

These movements, however, aren't necessarily only vertical or horizontal; they can be combined. This means that the relationship between the lens, the film, and the subject has an infinite number of potential positions. In most shooting situations, you will find that it is necessary to combine movements in order to achieve the exact picture you want. But you'll find that it is difficult to know what is happening as soon as the movements are combined. You must understand the type of effect each camera movement has on a subject to have control over what you're doing. You must have a starting point from which to proceed. This is the neutral or "0" position. Before you begin to shoot, the camera must be leveled from front to rear and from side to side. Centering the bubble levels ensures both that the monorail is level and that the front and back standards are vertical. Finally, the shutter must be open and the diaphragm must be set at its widest opening so that the image on the groundglass is as bright as possible.

Be aware that each time you swing or tilt either the lens or the back, you must refocus or recenter the image on the groundglass. This is because any time that the swings or the tilts are manipulated, the relationship between the groundglass and the optical center of the lens is altered. These changes are greater in cameras with base tilts than in cameras with tilts located at the center of the lensboard or the back.

You must also keep in mind that the image on the groundglass is upside down and backward. This is one of the most difficult concepts associated with operating a view camera, and it takes time to come to terms with. (You can, however, circumvent this problem by mounting a reflex viewing back on the camera in place of the normal groundglass. See page 20.) The diagrams included here show both the camera's position and how the block appears on the groundglass (upside down and reversed from side to side). Be aware that the enlarged illustration of the block in each section is the final print made from the image that appears on the groundglass. Finally, all of the photographs of the block were made at the largest diaphragm opening so that you can see exactly what the area of sharpness is; this eliminates any possible confusion created by stopping down the lens and increasing the depth of field.

# DEFINITIONS

The view camera is unique because its lens and back are not rigidly fixed in one position; they can be moved readily. These movements change the relationship between the film and the lens and consequently reposition the area of sharpness or alter the shape of the subject. Each movement produces a specific effect and is defined in relation to the camera's neutral position.

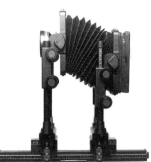

### Rise
The camera lens or back is raised vertically from the neutral position. This movement positions the lens higher than the film in relation to the camera bed or monorail.

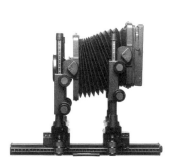

### Fall
The camera lens or back is lowered vertically from the neutral position. This movement drops the lens below the level of the film in relation to the camera bed or monorail.

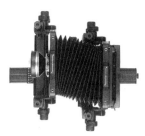

### Slide
The camera lens or back is moved horizontally from the neutral position. This movement displaces the lens or back from the center axis of the monorail or track and slides it to the left or right. Moving the lens causes one effect; moving the back causes a different one.

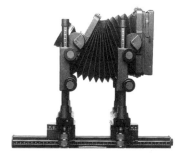

### Tilt
The camera lens or back is rotated around its horizontal axis. Again, the reference point is behind the camera. So, clearly, if you tilt the lens down, it will point toward the ground. If, on the other hand, you tilt the lens up, it will point toward the sky.

### Swing
The camera lens or back is rotated around its vertical axis. When you swing either the lens or the back, the reference position is behind the camera. So, for example, if you swing the lens to the right, it will point to the right. But if you swing the lens to the left, it will point to the left.

# LENS SLIDES, RISES, AND FALLS

Moving the lens up or down or from side to side changes the relationships between near and far objects. It also shifts the position of the image in the picture. The reason is simple. The lens is the part of the camera that "sees" the subject. So when the lens is moved, its relationship to various parts of the subject changes. If the lens is moved to one side of a subject, more of that side will be visible. And anything behind the front part of the subject will appear to have a different relationship to the rest of the subject.

You don't need a camera to observe this phenomenon. Just look at any two objects, one of which is behind the other. Cover one eye. Now if you move your head to one side, the foreground object will appear to have moved in the opposite direction in relation to the rear object.

You can observe another aspect of this phenomenon with three objects that are more or less in line behind each other. If you move your head to the right, both the front and center objects will seem to have moved to the left of the rear object. In addition, the foreground object will appear to have moved a great deal more than the center one.

In the accompanying photographs, what you see is not the way the image appears on the groundglass, but rather the final result of the camera movements as they affect the final print. The small diagram behind the camera shows how the image appears on the groundglass. Finally, the photographs of the ball and blocks were made at the widest possible diaphragm opening so that you can see the plane of sharp focus more clearly.

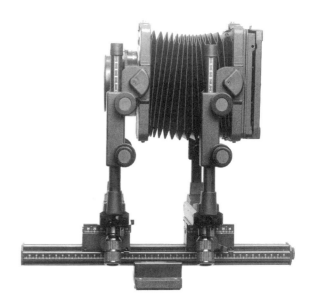

### The Starting Setup
The camera lens, the ball, and the blocks are all centered so that the image on the groundglass is of only the ball centered on the blocks. The image itself is centered on the groundglass. All of the camera controls are in the neutral position.

## LENS NEUTRAL

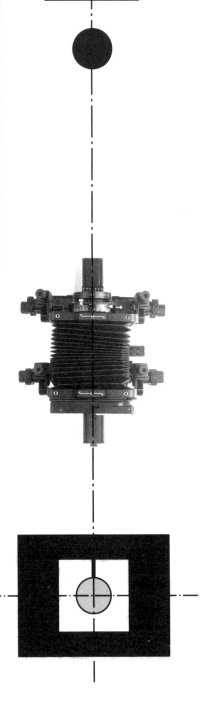

### Image is centered on groundglass.
### In final print, cube of blocks is centered,
### ball is centered.

This is the neutral position as seen from the top. The ball is centered on the blocks, from side to side and from top to bottom. In addition, the image is centered in the picture.

## LENS SLIDES LEFT

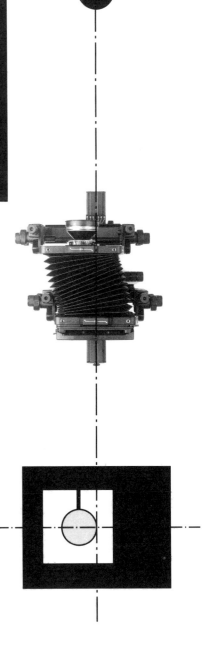

### Image moves left on groundglass.
### In final print, cube of blocks moves
### right, ball moves right.

When the lens slides to the left, the entire image shifts to the right in the final print. Note that the ball moves to the right in relation to the blocks. The ball no longer touches the "O" or the "2" in the cube of blocks; however, both the "R" and the "S" are somewhat obscured. Also, the centerpost supporting the ball moves to the right of the blocks' centerline.

## LENS SLIDES RIGHT

### Image moves right on groundglass.
### In final print, cube of blocks moves left, ball moves left.

When the lens slides to the right, the image on the groundglass also moves right. In the final print, the image shifts to the left, with the ball moving left in relationship to the blocks. The "O" and the "2" are almost covered now, while the "R" and the "S" are completely visible. The centerpost of the ball moves to the left of the blocks' centerline.

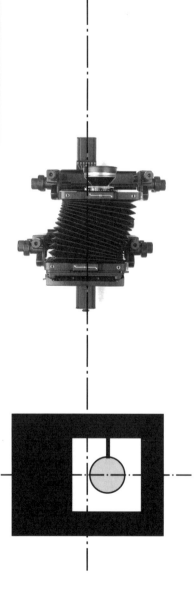

# LENS NEUTRAL

**Image is centered on groundglass.**
**In final print, cube of blocks is centered, ball is centered.**
This is the neutral starting position as seen from the side.

## LENS RISES

### Image rises on groundglass. In final print, cube of blocks falls, ball falls.

When the lens is raised above the blocks' centerline, the image on the groundglass also rises. In the final print, the image moves down and the ball drops down in relation to the block. The "T" and the "I" are completely visible, while the "E" and the "P" are almost obscured.

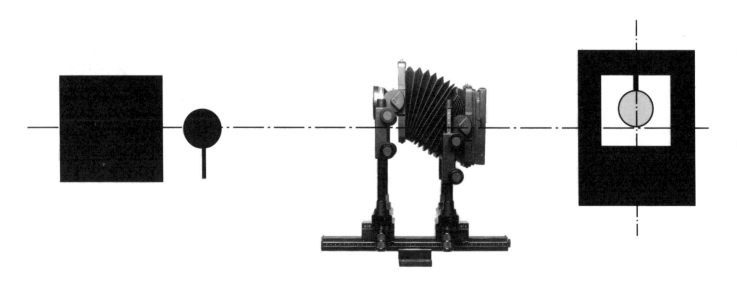

## LENS FALLS

### Image falls on groundglass. In final print, cube of blocks rises, ball rises.

When the lens is lowered below the camera's centerline, the image on the groundglass also moves down. In the final print, the blocks move up and the ball moves up in relation to the blocks. The "T" and the "I" are now covered, while the "E" and the "P" are visible.

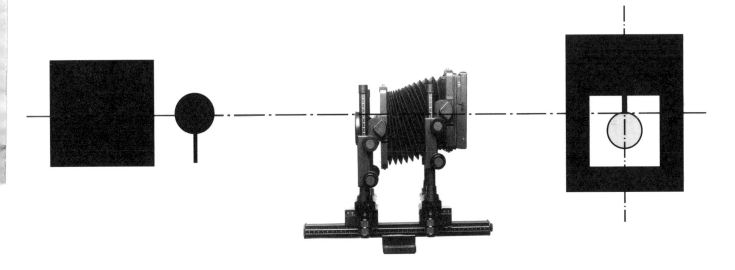

# Back Slides, Rises, and Falls

Sliding the camera back vertically or horizontally shifts the image position on the film without changing the camera's point of view in relation to the subject. The image itself doesn't move; it remains stationary while the back is moved so that the image falls on a different section of the film. The position of the image depends on the direction in which the film shifts. This is the primary control for centering the image on the groundglass after the picture is set up.

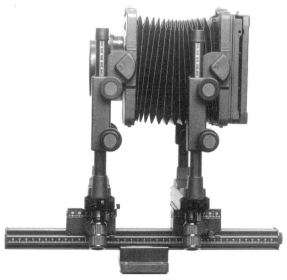

**The Starting Setup**
The camera lens, the ball, and the cube of blocks are all centered so that the image on the groundglass shows the ball centered on the cube of blocks. All camera controls are in the neutral position.

# BACK NEUTRAL

## Image is centered on groundglass.
## In final print, cube of blocks is centered,
## ball is centered.

This is the neutral position as seen from the top.
All camera controls are in neutral. The camera
lens, the ball, and the cube of blocks are all
centered on a single line; the image on the
groundglass shows the ball centered on the cube.
The resulting image is centered on the film.

## BACK SLIDES LEFT

### Image moves right on groundglass. In final print, cube of blocks moves left, ball moves left.

When the camera back slides to the left, the image on the groundglass moves to the right. The entire image moves left in the final print without changing the relationship between the ball and the cube.

## BACK SLIDES RIGHT

**Image moves left on groundglass.
In final print, cube of blocks moves
right, ball moves right.**

When the camera back slides to the right, the
image moves to the left on the groundglass. The
ball remains centered on the cube, and the entire
image moves to the right in the final print.

## BACK NEUTRAL

**Image is centered on groundglass.**
**In final print, cube of blocks is centered, ball is centered.**
This is the neutral position as seen from the side. Here, too, the lens, the ball, and the cube are all centered on a single line, and the resulting image is centered on the film.

# BACK RISES

### Image falls on groundglass. In final print, cube of blocks moves up, ball moves up.

When the camera back is raised, the groundglass image shifts down. The ball and the blocks move up in the final print. There is no change in the relationship between the ball and the cube of blocks.

## BACK FALLS

**Image rises on groundglass.
In final print, cube of blocks
moves down, ball moves down.**
When the camera back is lowered below
the lens' centerline, the groundglass
image moves up. The image moves
down in the final print. Again, there is
no change in the relationship between
the blocks and the ball.

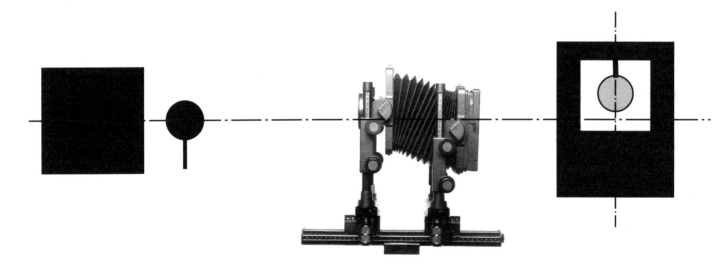

# LENS SWINGS AND TILTS

When the lens is focused on a subject, everything on one of the subject planes will be in sharp focus as long as that subject plane and the lens and film planes are parallel. This plane of sharp focus is parallel to the lensboard and perpendicular to the optical axis of the lens. The camera movements that are responsible for controlling the position of this plane of sharp focus are the lens swings and tilts.

If the camera is tilted in relation to the subject, the subject plane that is in sharp focus will also tilt as long as the lens and film planes remain parallel. Swinging the lens from side to side or tilting it up or down around its optical center repositions the plane of sharp focus without distorting the shape of the subject or its position on the groundglass.

When the lens is rotated around its optical center axis, however, this plane of sharp focus also rotates so that it is no longer parallel to the film plane. This is because one edge of the lens is now farther from the film than the other. To get everything in sharp focus, you must employ the *Scheimpflug effect*: *When the plane of the film, the plane of the lens, and the plane of the subject all meet at a common point, everything lying on the plane of the subject will be in sharp focus.* The actual technique of adjusting the lens, the film, and the subject planes to meet at a common point is to tilt the lens plane and adjust the focus at the same time, while looking at the image on the groundglass.

When a flat surface is photographed at an angle using a camera with a rigid lens mount, focusing on the near side of the subject leaves the distant part out of focus. If you refocus on the distant part of the surface, the near part goes out of focus. The only way to get both edges sharp is to focus on some point between them and then stop down the aperture to increase the depth of field. If the subject's edges are quite far apart, however, the chance that everything will be in sharp focus is unlikely. When this situation happens, you can cheat a bit by placing the focus slightly more on the near part of the subject; if the far part is slightly unsharp, it isn't as noticeable.

For a photographer working with a view camera, using the Scheimpflug effect is the simplest solution to this problem. This effect enables you to position the plane of sharp focus by tilting or swinging the lens so that the three planes—the lens, the film, and the subject planes—all intersect at the same point. When you adjust the camera this way, everything on the subject plane will be in sharp focus even when the lens is opened to its widest aperture. Interestingly enough, the depth of field doesn't remain even over the entire subject plane; it becomes greater at the far end of the subject and less so at the near end. This increases the possibility of keeping tall objects in sharp focus while the horizontal subject plane stays sharp, but careful positioning of the plane of sharp focus is required.

Keep in mind that the Scheimpflug effect pertains to the lens, the film, and the subject planes, regardless of where the subject plane happens to be. In other words, if you want to bring a wall into sharp focus, swing the lens to the side. If the subject is on the ceiling, tilt the lens up.

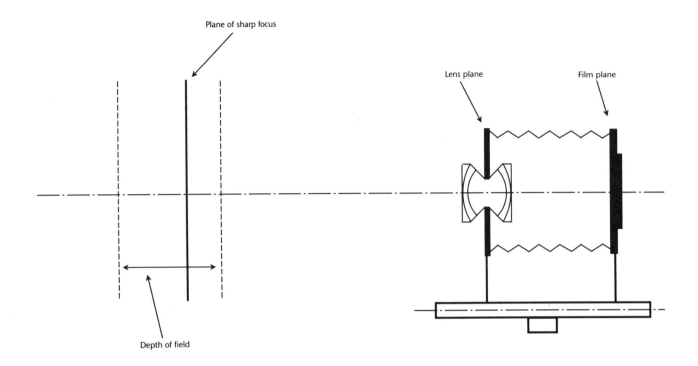

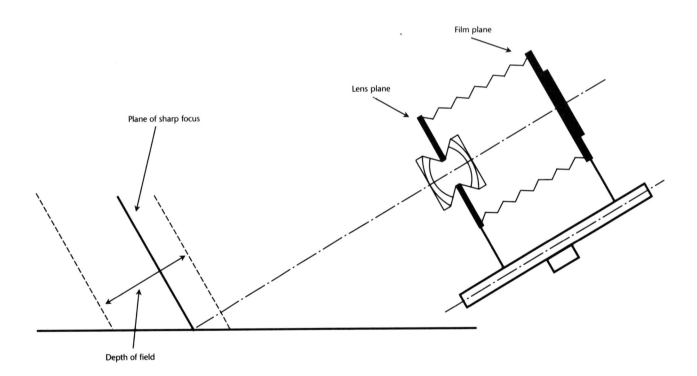

When the lens, film, and subject planes are parallel (top),
everything on that particular subject plane is in sharp focus.
When the lens plane isn't parallel film plane, you must adjust
the lens, film, and subject planes so that they meet at a
common meeting point (bottom). This is known as the
Scheimpflug Effect.

# LENS SWINGS

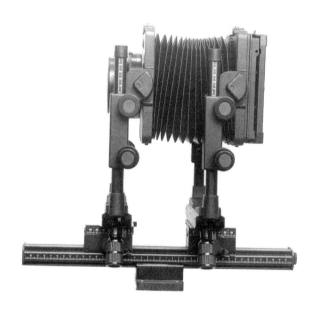

## The Starting Setup

The cube of blocks is positioned at a 45-degree angle to the lens and is centered on the film.

**LENS NEUTRAL**

**Image is centered on groundglass.**
**In final print, image is centered.**
**Depth of field is shallow.**

This is the neutral camera position as seen from the top. The focus is biased toward the front edge of the cube, which throws both rear corners of the cube out of focus.

# LENS SWINGS LEFT

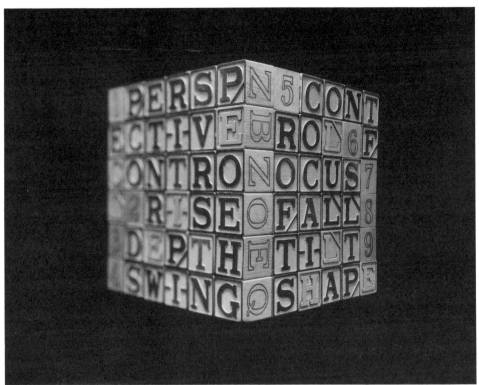

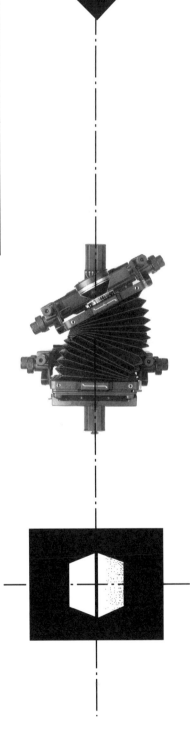

**Left side of cube of blocks is sharp on groundglass.**
**In final print, right side of cube of blocks is sharp.**

The camera lens is swung toward the left, so the plane of the right side of the cube, the lens plane, and the film plane all meet at a common point. In the final print, the right side of the cube appears sharp from front to rear. However, the left side is considerably more out of focus.

# LENS SWINGS RIGHT

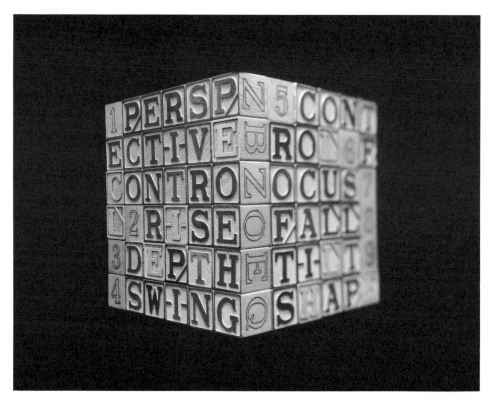

**Right side of cube of blocks is sharp on groundglass.**
**In final print, left side of cube of blocks is sharp.**

When the camera lens swings to the right, the plane of the blocks' left side, the lens plane, and the film plane all meet at a common point. In the final print, this movement makes the left side of the blocks sharp from front to rear, and the right side of the blocks is more out of focus.

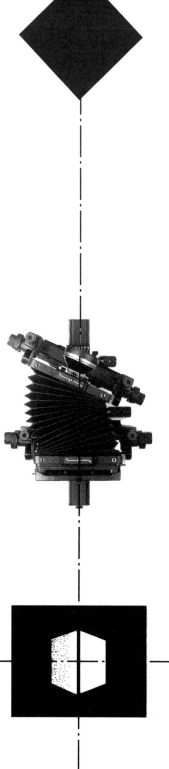

# LENS TILTS

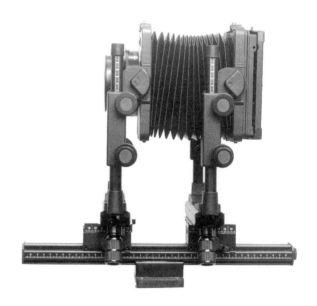

## The Starting Setup
The cube of blocks is set up at a 45-degree angle to the lens and centered on the film.

# LENS NEUTRAL

**Image is centered on groundglass.**
**In final print, image is centered.**
**Depth of field is shallow.**

This is the neutral camera position as seen from the side. The focus is on the front corner of the cube, which makes the back edges unsharp.

## LENS TILTS UP

**Top of cube of blocks is sharp on groundglass.**
**In final print, bottom side of cube of blocks is sharp.**

The lens is tilted upward so that the plane of the blocks' bottom side, the lens plane, and the film plane all meet at a common point. In the final print, the bottom is in sharp focus from front to rear, but the top is less sharp.

## LENS TILTS DOWN

**Bottom of cube of blocks is sharp on groundglass.**
**In final print, top of cube of blocks is sharp.**
When the lens is tilted down, the plane of the top of the cube, the lens plane, and the film plane meet at a common point. In the final print, the top is sharp while the bottom goes out of focus.

# BACK SWINGS AND TILTS

Pivoting the camera back changes the shape of the subject by elongating one side and compressing the other. The effect is horizontal when the back is swung and vertical when it is tilted. This happens because the farther the groundglass is from the lens, the larger the image becomes. When the groundglass is pivoted around its center, the center of the image doesn't change position and therefore that part of the subject remains the same size. The image on the part of the groundglass that moves away from the lens becomes larger; conversely, the area of the subject on the part that moves closer to the lens becomes smaller. If the subject is square, it will become trapezoidal in shape.

In the top diagram opposite, note that parts A and B of the subject are exactly the same size. When projected onto the film plane parallel to the subject plane, A and B remain equal. The bottom diagram opposite shows what happens when you tilt the back up. Keep in mind that the tilt takes place on the central axis, so the center of the film plane remains in exactly the same position and at exactly the same distance from the lens as it was before the film plane was tilted. Notice where edge 1 is on the subject and the place where it falls on the film plane. Because the film plane is now tilted, the part where edge 1 intersects it is now much closer to the lens than the centerline at edge 3. Since part B is closer to the lens, it is compressed; this makes it shorter than it was before.

Conversely, edge 2 falls on the film plane considerably farther away from the lens; it intersects the film plane at a greater distance from the centerline. The segment from the centerline at edge 3 to edge 2 is now much larger. The image appears to have shifted its position on the film, in effect moving toward the side where the image became larger. Actually, what has happened is that edge 1 falls on the film plane closer to the centerline than before, and edge 2 falls on the film plane farther away from centerline 3, creating the impression that the image has shifted its position on the film. This off-center appearance can be corrected by raising the camera back.

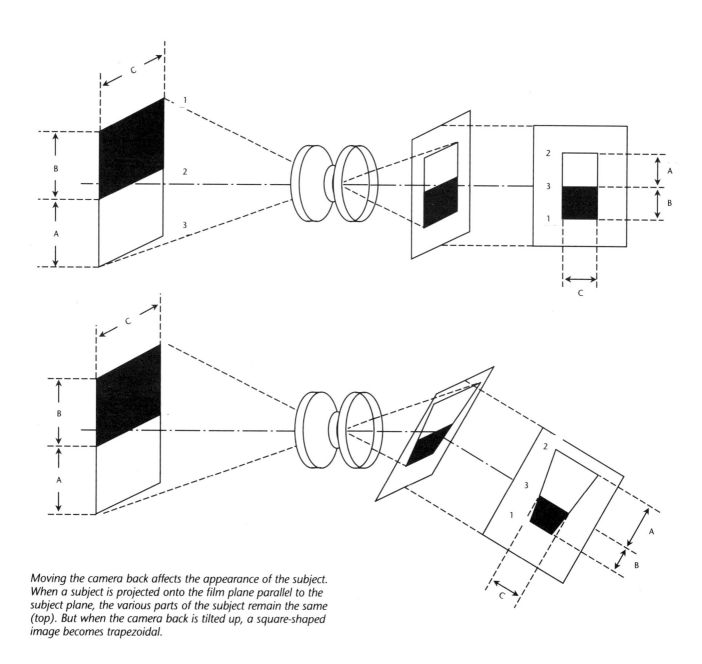

*Moving the camera back affects the appearance of the subject. When a subject is projected onto the film plane parallel to the subject plane, the various parts of the subject remain the same (top). But when the camera back is tilted up, a square-shaped image becomes trapezoidal.*

# BACK SWINGS AND TILTS

## The Starting Setup

The camera is centered vertically and horizontally with the front surface of the cube. The image is centered on the groundglass, and the front surface of the cube, the lens, and the film are all in parallel planes.

## BACK NEUTRAL

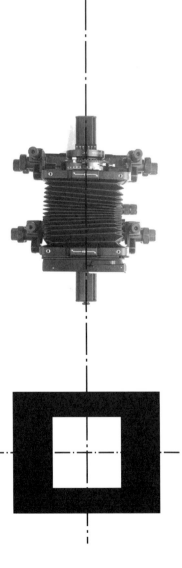

**Image is centered on groundglass.**
**In final print, image is centered.**

With the camera in the neutral position, the back, the lens, and the blocks' surface are parallel. The image is square, having the same dimension on all sides.

## BACK SWINGS RIGHT

**Right side of cube of blocks gets larger on groundglass.**
**In final print, left side of cube of blocks gets larger.**

When the right side of the back is moved away from the lens, the right side of the image of the cube gets larger on the groundglass. The left side of the image of the cube gets larger in the final print. Note that the vertical lines remain parallel although their spacing is now narrower on the right side of the picture and wider on the left side. The blocks' centerline remains in the center of the picture.

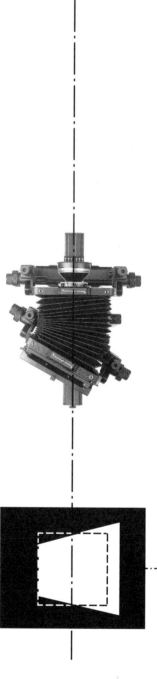

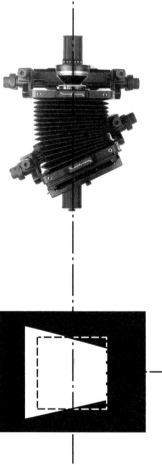

### Left side of cube of blocks gets larger on groundglass.
### In final print, right side of cube of blocks gets larger.

Moving the left side of the back away from the lens makes the left side of the image on the groundglass larger and the right side of the cube larger in the final print. The left side of the cube becomes smaller in the print because the right side of the film moved closer to the lens. The center remains the same size.

**Image is square on groundglass. In final print, image is centered and square.**

This is the neutral position as seen from the side. The image of the cube is centered and square.

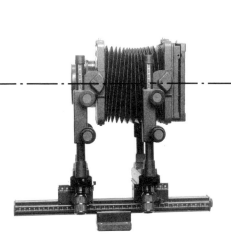

# BACK TILTS UP

**Top of cube of blocks gets larger on groundglass.**
**In final print, bottom of cube of blocks becomes larger.**
The camera back is tilted upward, which moves the bottom of it closer to the lens. The top of the image then gets larger on the groundglass. In the final print, the cube appears to move downward and the bottom becomes larger.

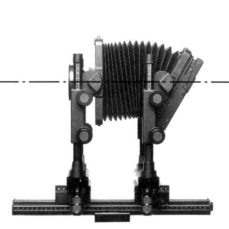

## BACK TILTS DOWN

**Bottom of cube of blocks gets larger on groundglass.**
**In final print, top of cube of blocks gets larger.**

As the camera back is tilted down, the bottom moves farther from the lens and the top moves closer. The result is that the bottom gets larger on the groundglass. In the final print, the cube seems to move upward and the top becomes larger.

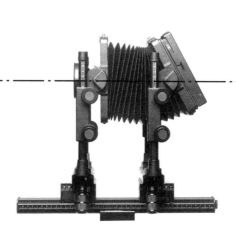

## Chapter Five

# CONTROLLING IMAGE SHAPE

When you look at a subject, you are aware of its actual shape because you know that parallel lines appear to converge or diverge and objects seem smaller the farther away they are. However, when you look at a picture of this same subject, converging vertical lines seem unnatural. The subject appears distorted, and you get the impression that it is about to fall over. It is possible, though, to change this so that the subject looks normal and doesn't seem to be about to fall. But—and this is important to remember—you aren't correcting the shapes; you're distorting them so that they appear the way you think they should look.

Image shape is controlled by swinging or tilting the camera back; the degree to which horizontal or vertical lines in the image converge or diverge is determined by how far the back is swung or tilted. Both swings and tilts may be used simultaneously. In every case, the image is displaced on the groundglass; therefore, it is necessary to use back slides, rises, falls, or a combination of them to recenter the image.

As the back pivots around its center, one side moves farther from the lens and the other gets closer to it. Remember: the farther the groundglass is from the lens, the larger the image is on that side of the groundglass. Conversely, on the side closer to the lens the image becomes smaller. At the center, where the lens-to-groundglass distance doesn't change, the image remains the same size.

Controlling the shape of the image can be carried out in only one plane at a time. When you make changes in any of the camera settings to control the lines in one plane of the picture, you increase the distortion in other planes. Before you make any camera movements, therefore, you must study the subject carefully, determine the area of greatest importance, and decide which areas can stand the most distortion.

One optical fact of life is that circular objects become elliptical the farther they are from the center of the groundglass; also, their horizontal and vertical axes incline away from the vertical and horizontal planes the closer they are to the corners of the photograph. This is particularly noticeable with wide-angle lenses, but is true to some extent with all lenses. It is useful to understand that the longer the lens' focal length, the less of this type of distortion is introduced into the picture.

# SHAPE CONTROL: BACK SWINGS

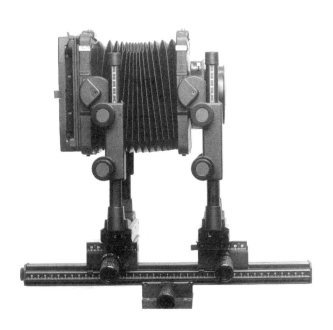

## The Starting Setup

The cube of blocks is positioned vertically and at a 45-degree angle to the lens; the image is centered on the film. The ball is positioned at the far right edge of the cube and centered.

# CAMERA NEUTRAL

**Cube of blocks is symmetrical on groundglass.**
**In final print, cube of blocks is centered.**
With the image centered in the neutral position, the tallest segment is the vertical centerline of the cube. Both sides of the cube are symmetrical in shape, and the ball is perfectly round.

## BACK SWINGS RIGHT

### Right side of image becomes larger on groundglass.
### In final print, left side of image becomes square.

Swinging the camera back to the right causes the converging lines on the left side of the picture to spread out and square up that part of the image. The horizontal lines become elongated, and the left side of the blocks gets considerably wider than it was in the neutral camera position. On the right side of the blocks, the horizontal lines converge even more, resulting in a height reduction of approximately 20 percent. The ball also becomes smaller and flattens into a slightly horizontal oval.

**BACK SWINGS LEFT**

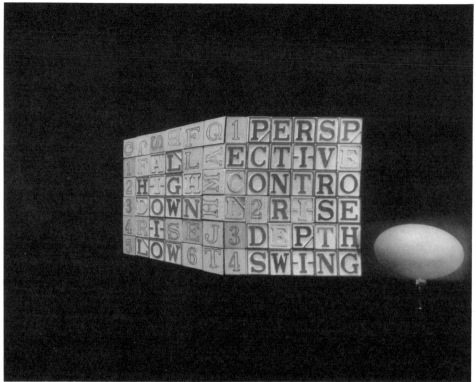

## Ball and left side of cube of blocks become larger on groundglass.
## In final print, right side of image becomes square.

Swinging the camera back to the left reverses the effect created in the previous illustration. However, the ball becomes 50 percent taller than it was and more than twice as wide as in the neutral camera position. This is considerably more of a change than occurs in the cube, which widens by only 50 percent. The blocks' rear edge becomes only 20 percent taller. The ball becomes much larger because the farther a subject is from the centerline, the greater the amount of change that takes place as the camera back swings to another position.

# SHAPE CONTROL: BACK TILTS

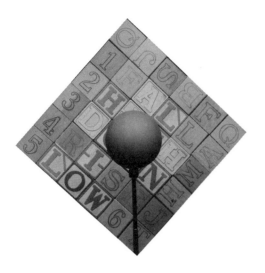

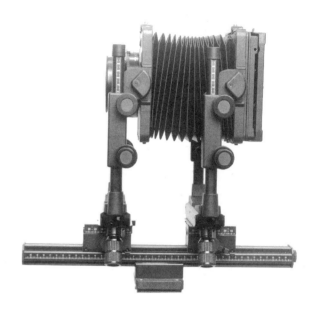

## The Starting Setup

The cube is positioned horizontally at a 45-degree angle to the lens and centered so that the image is correspondingly centered on the film. The ball is positioned on the far left side of the cube and centered horizontally.

## CAMERA NEUTRAL

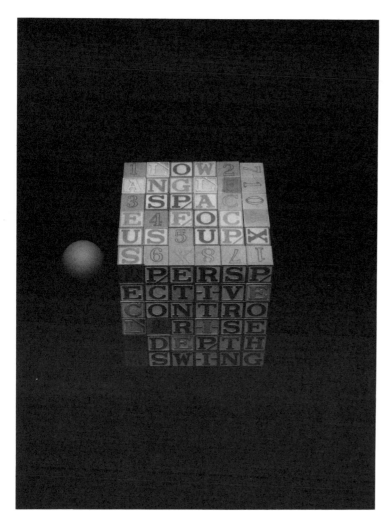

**Image is centered on groundglass.
In final print, cube of blocks is centered, ball is centered.**
With the image centered in the neutral position, the widest part of the cube is the horizontal centerline. Both the top and the bottom are symmetrically shaped, and the ball is perfectly round.

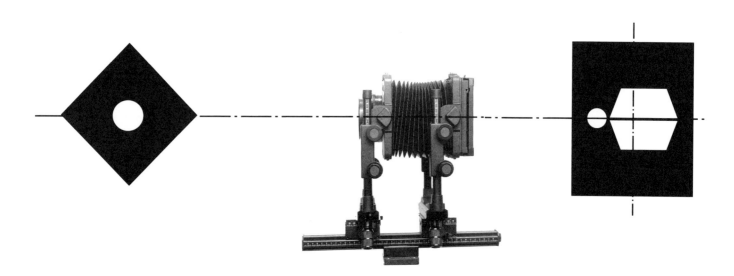

## BACK TILTS DOWN

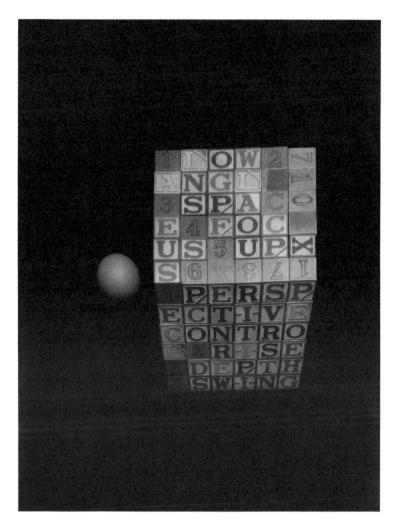

**Bottom of cube of blocks becomes wider on groundglass. In final print, top of cube of blocks becomes square.**
Tilting the back down causes the converging lines at the top of the cube to spread out and square up. The bottom lines converge more and become shorter. There is practically no change in the size or the shape of the ball because it is located on the centerline.

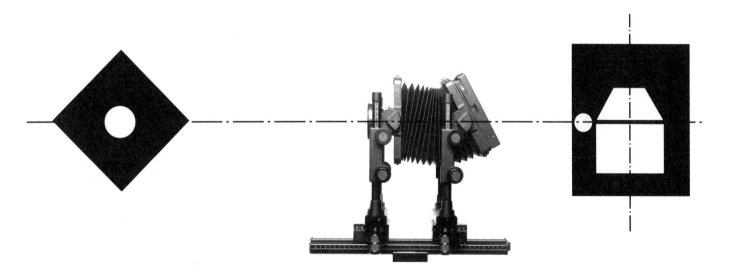

## BACK TILTS UP

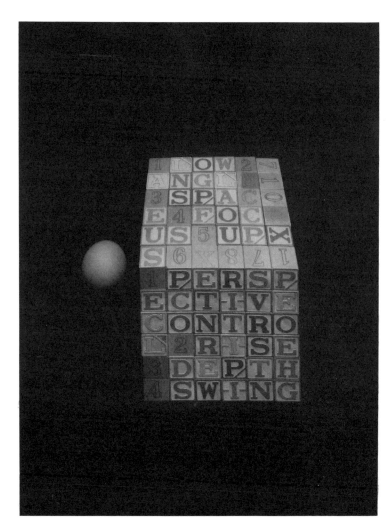

**Top of cube of blocks spreads out on groundglass.**
**In final print, bottom of cube of blocks becomes square.**
Tilting the back up enlarges the bottom of the cube and compresses the size of its top. Again, because the ball is located on the centerline, there is no distortion in its shape.

# ADVERSE YAW

One of the the most frustrating and confusing effects that you will encounter when controlling image shape with view-camera movements is an optical misalignment called *adverse yaw*. This occurs when the camera is pointed up or down while the back is simultaneously tilted and swung. This combination of movements is often used when shooting a tabletop or still-life setup from above or when pointing the camera up to photograph a tall building. The purpose of these movements is to maintain the parallel lines of the subject accurately and to control the plane of sharp focus. The following steps show where adverse yaw comes into play.

When setting up a picture, you first tilt the camera up or down to frame the subject. When you do this, the groundglass is no longer positioned directly over the central axis of the camera's back standard but is in front of or behind that point instead. The second step is to tilt the back and lens so they are once again vertical; this makes a subject's parallel sides appear parallel and in sharp focus on the groundglass.

It is the third step that causes adverse yaw; occasionally it is necessary to swing the back either to control the horizontal lines in the subject or to reposition the plane of sharp focus (remember, with the camera tilted up or down, the groundglass is no longer directly over the center axis). Therefore, when you swing the back, it swings in an arc rather than pivots around its center axis, and the result is that the back leans to one side. For this reason, the image no longer appears upright on the groundglass; it is tipped at an angle and is displaced to the side. Additionally, one side is enlarged and the other compressed because one corner is now farther away from the film and the one diagonally opposite it is now closer to the film. This creates the distortion of adverse yaw.

To prevent the distortion of adverse yaw, you must keep the camera back directly above its pivot point so that it rotates when the back is swung, rather than swinging in an arc. To do this, first level the camera by using the built-in bubble

levels. Then, if you want to look up at the subject, as when photographing a tall building, raise the lens and drop the back. This enables you to record more of the upper part of the building and less of its base. If you need to look down on the subject, as when shooting a tabletop, the opposite movement is called for: drop the lens and raise the back. If you then need to pivot the back to control the linear convergence of the horizontal lines, the rotation will occur directly over the central pivot point, thereby avoiding adverse yaw.

There are three limitations to these camera movements. The first is how far you can raise the lens and lower the back before you come to the limit of the camera's rise and fall movements. The second constraint is the physical limit imposed by the camera bellows. A normal bellows is not particularly flexible, and there is quite a bit of it because it must be long enough for use with long-focal-length lenses. The third limitation is the most difficult to overcome because it is imposed by the optical limits of the circumference of the lens' image circle: the larger the image circle, the farther you can raise or lower the lens and still get an image on the groundglass (review the material in Chapter 3 on both circle of coverage and angle of view.)

Another way to avoid adverse yaw is to use a camera that is equipped with base tilts rather than center tilts. When you point the camera up or down in order to cover the subject and then tilt the back and lens standards until they are vertical, both will be positioned over their central pivot points. When the back swings, adverse yaw won't occur.

Cameras with bottom-tilts are limited by two factors. First, if the camera is tipped up or down too far, it might not have enough tilt movement to permit the back and lens to become completely vertical. The second limitation is the optical problem mentioned earlier: the covering power of the lens. The size of the image circle is the limit of how far you can raise or lower the lens. Using a lens that has an extremely wide angle of coverage can help.

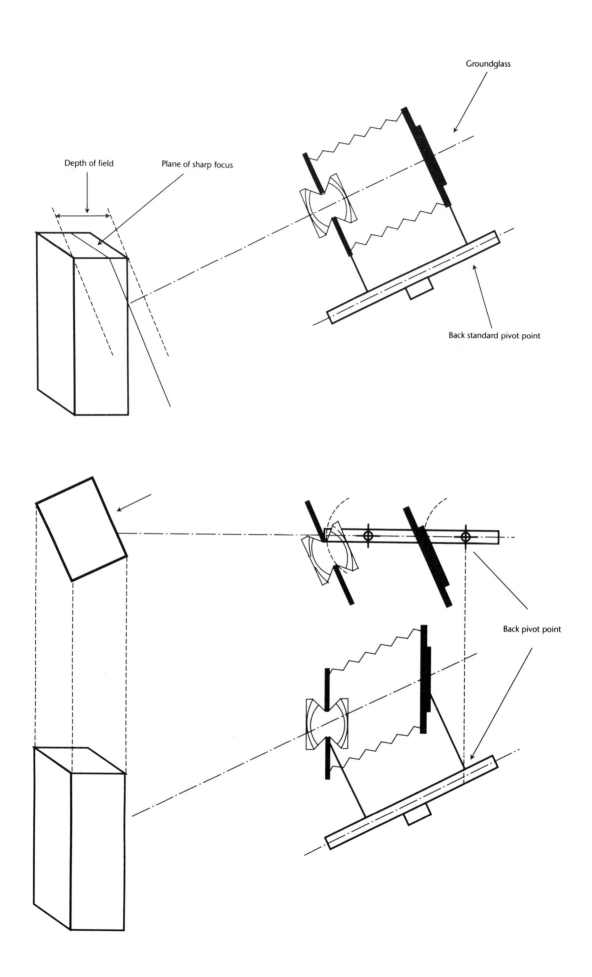

Depth of field

Plane of sharp focus

Groundglass

Back standard pivot point

Back pivot point

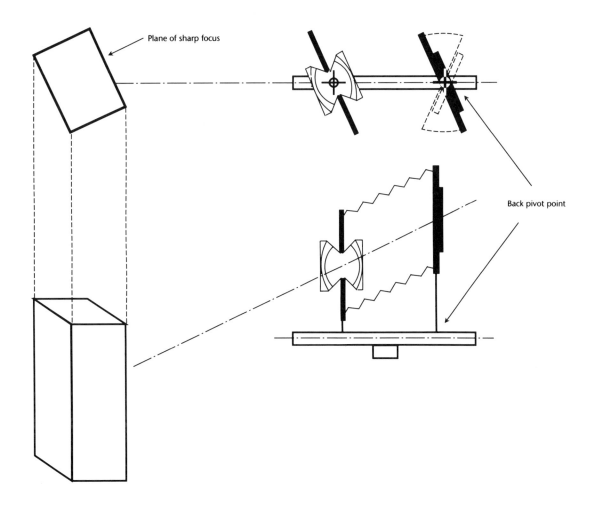

Plane of sharp focus

Back pivot point

The top illustration on the opposite page shows the camera being tilted down to frame the subject; all camera controls are in the neutral position. The bottom illustration opposite shows what happens when the camera remains tilted down and the back and lens swing in an arc. Adverse yaw results: the image on the groundglass is tipped at an angle and displaced to the side. In addition, one side of the image is enlarged and the other compressed. To prevent this distortion, the back must be positioned directly over its pivot point. It then rotates rather than swings in an arc, as shown in the illustration above.

# CAMERA MOVEMENTS AND ADVERSE YAW

The four series of illustrations on pages 102-117 clearly show how the image shape can be manipulated and which compound movements of the camera back cause adverse yaw. Each series features a simple setup consisting of a box and an orange on a plate, and each illustrates what happens to three basic shapes—an oval, a rectangle, and a sphere—as the camera back tilts and swings at the same time.

## Series 1:

The camera is tilted down, and the back is in the neutral position. Because the back rotates directly over the pivot point, no adverse yaw results.

## Series 2:

The camera is tilted down, and the back is erected to the vertical position. Under this condition, the back swings in an arc, which causes a small amount of adverse yaw. When the back is swung in the B and C positions, most of the adverse yaw can be corrected by using the camera side-to-side tilt.

## Series 3:

The camera is tilted down, and the back is tilted farther back beyond the vertical plane so that it is pointed up. With this amount of tilt, adverse yaw is excessive and can't be corrected in the B and C swings.

## Series 4:

The camera is tilted down, and the back is tilted forward, pointed down even more than the neutral position. Once again, adverse yaw is extreme and can't be corrected for either the B or the C back swings.

A series of three photographs was made with the back tilted in each of the above positions: with the back centered, with the back swung right, and with the back swung left. The following series of diagrams show what happens when swings are introduced.

In the A position, the back is set in neutral with no swings introduced. As a result, it is possible to compare the relative width of the two segments of the subject.

In the B position, when the back was swung left so that the right side of the back moved closer to the lens, the width of the box was compressed while the width of the plate and the orange expanded.

In the C position, the back was swung right so that its left edge moved closer to the lens. In this position, the plate and orange are narrower, while the box on the right side of the groundglass is wider because that side of the back is now farther from the film plane. In addition to changing width, the shape was distorted and axial lines changed direction and shifted position on the groundglass because of the adverse yaw introduced when the camera back was swung. Before the exposure was made, the image had to be recentered on the groundglass.

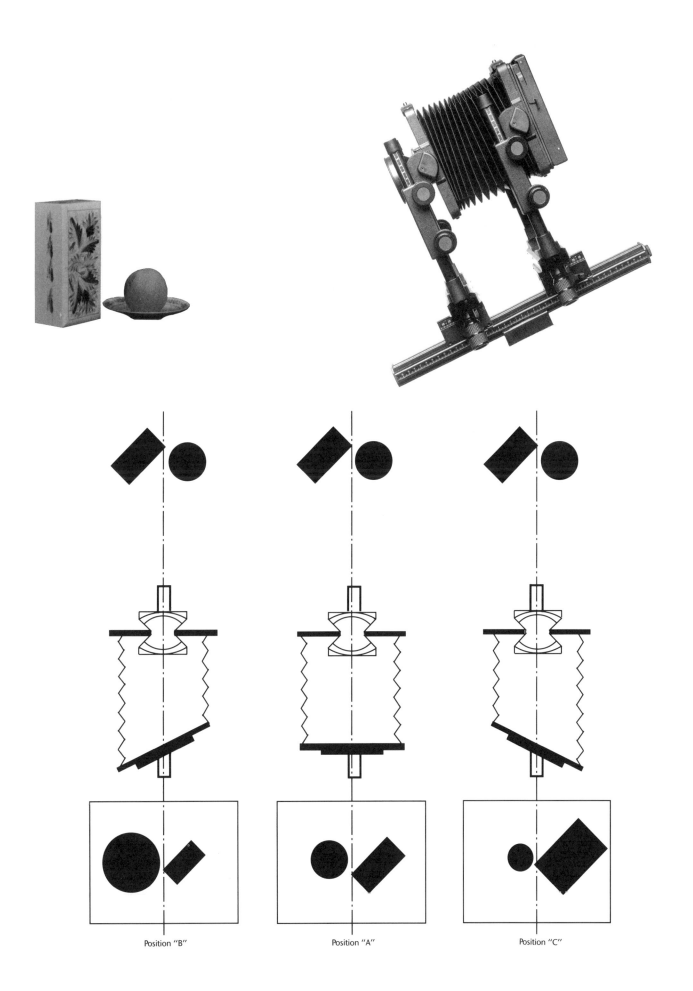

Position "B"

Position "A"

Position "C"

# Adverse Yaw: First Series

## The Starting Setup

The camera is set up above the subject and pointed down toward it. All other controls are in the neutral position.

**BACK NEUTRAL**

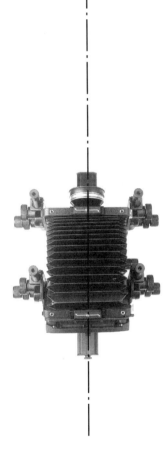

In this position, the back controls are neutral, and the camera is tilted down approximately 20 degrees so that the image is centered. The box is turned at approximately a 20-degree angle to the lens plane. Because the camera is tilted down, the bottom of the box is farther away than the top, and consequently it is smaller. This gives the box a trapezoidal shape with sides that converge toward the bottom. Because the right edge of the box is near the center of the picture, it doesn't taper inward as much as the left edge that is farther away from this central axis.

## BACK SWINGS LEFT

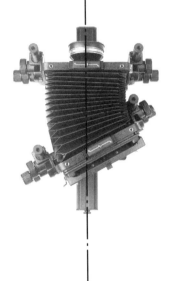

The camera back swings left, almost parallel with the front of the box. This means that the right side of the film is now closer to the camera lens than before, and the left side is now farther away. The result in the final print is that the box is narrower and the left side is shorter, bringing the top and bottom of that side closer together and making them more nearly parallel. At the same time, because the left side of the film plane is farther away, the orange expands, becoming broader and taller. This same expansion changes the angle of the plate's axis, resulting in an egg-shaped elongation.

## BACK SWINGS RIGHT

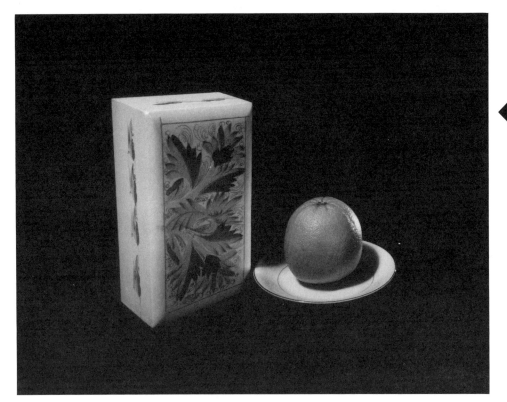

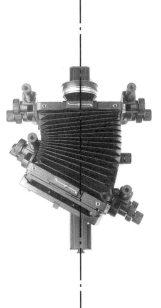

The camera back swings right, away from the front of the box. As a result, the right side of the camera back is farther away from the lens and the left side of the back is closer to the lens. Consequently, in the final print the image of the box is stretched to the left and the left edge is elongated. The angle created by the right side of the base of the box is more acute now because of the expansion of the left side of the box. The central axis of the plate swings around to the horizontal, a result of the compression of this side of the image. This same compression makes the orange slightly smaller and also shifts the axis of the plate.

# ADVERSE YAW: SECOND SERIES

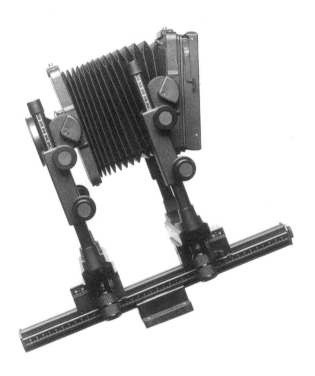

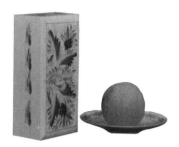

## The Starting Setup

The camera and the box are set up, and the camera back is tilted so that it is vertical. Again, a series of exposures was made with the camera at neutral, with the back swung left, and with the back swung right.

## BACK ERECT
## NO SWINGS

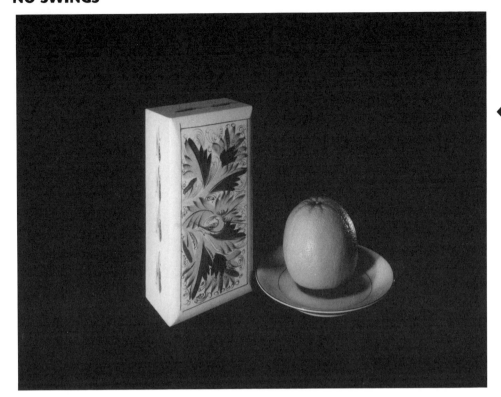

The camera and subject are set up, and the camera back is tilted so that it is vertical. No back swings are used. As a result, the bottom of the box expands slightly and the top becomes smaller. The right and left edges of the box are parallel to each other instead of converging toward the bottom, as they do in the first series. Because of this, the left side of the box becomes slightly longer and its base creates a more acute angle, giving the whole box an elongated, more pointed appearance. This distortion is also visible in the orange; it is taller than it was in the uncorrected image in series 1, position A.

## BACK SWINGS LEFT

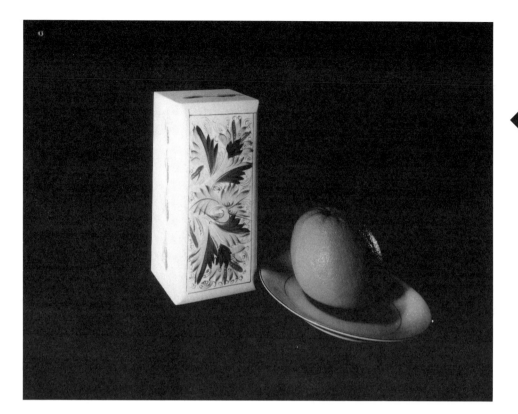

The camera back swings left, almost parallel with the front of the box. As a result, the right side of the film is now closer to the lens, and the left edge of the box is shortened so that the top and bottom of the box are more nearly parallel and more square. The orange and plate become larger because the left side of the film is farther away from the lens. This expansion causes the axis of the plate and the orange to shift away from the almost horizontal direction they were in at position A. Consequently, both the orange and the plate are elongated and broadened along the axis of the plate.

## BACK SWINGS RIGHT

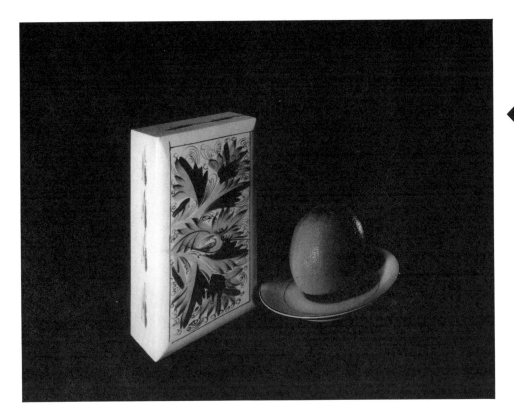

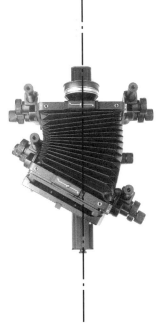

With the back still in the vertical position, it now swings right, away from the front of the box. This makes the box broader, and the left side of the box, being farther from the center of the picture, becomes elongated. The right and left sides of the box are still parallel. The right side of the image, being closer to the lens, becomes shorter, resulting in a dramatic shift in the axis of the plate. This movement also compresses the height of the orange, flattening the image so that it is almost as broad as it is high.

# ADVERSE YAW: THIRD SERIES

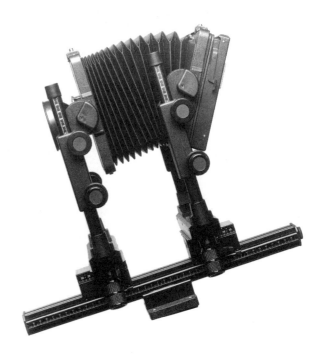

## The Starting Setup

The camera is set up with the back tilted beyond the vertical so that it points upward. Again, three exposures were made with the back neutral, swung left, and swung right.

## BACK TILTS UP
## NO SWINGS

The camera and subject are set up as in series 1, position A. Then the camera back is tilted beyond the vertical plane so that the top of the back is farther away from the box than the bottom of the back is. As a result, the box elongates: the top is narrower, and the bottom is broader. The same effect happens to a lesser degree to the plate and the orange because their tops and bottoms are not as far away from the horizontal central axis of the picture.

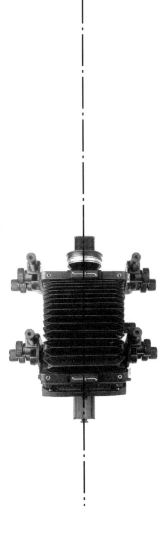

# BACK SWINGS LEFT

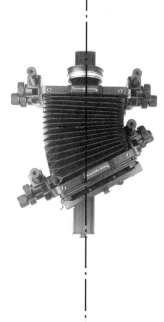

The back swings left until it is nearly parallel with the front of the box. The result is a squaring up of the box because the right side of the back comes closer to the lens. Consequently, there is a marked shortening of the left side of the box. The left side of the back moves away from the lens, causing an excessive elongation of the elliptical shape of the plate and the egg shape of the orange. This also causes the broadening of the image, especially in terms of the width of the plate. Notice how the right side of the box, which is close to the central axis of the picture, is tipped to the left because of adverse yaw.

## BACK SWINGS RIGHT

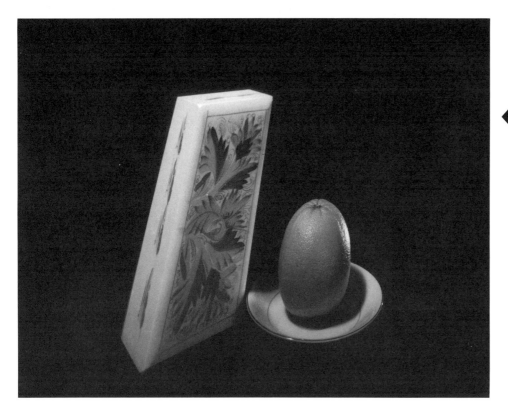

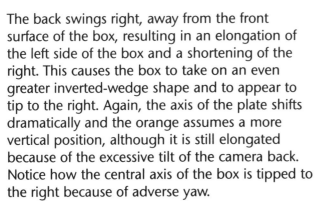

The back swings right, away from the front surface of the box, resulting in an elongation of the left side of the box and a shortening of the right. This causes the box to take on an even greater inverted-wedge shape and to appear to tip to the right. Again, the axis of the plate shifts dramatically and the orange assumes a more vertical position, although it is still elongated because of the excessive tilt of the camera back. Notice how the central axis of the box is tipped to the right because of adverse yaw.

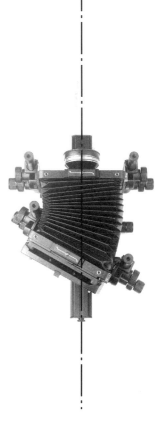

# ADVERSE YAW: FOURTH SERIES

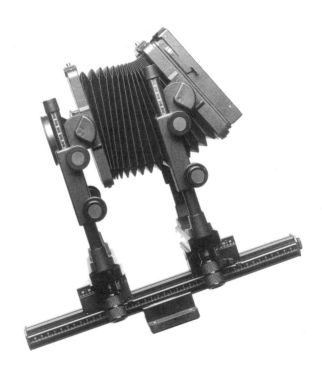

## The Starting Setup

In this final position, the back of the camera is tilted forward from the neutral position so that it is actually pointed down. Exposures were made without swings, swung left, and swung right.

## NO SWINGS

The camera is set up as in series 1, position A. The camera back is then tilted down, moving its plane even farther away from the vertical axis. Now the distortion occurs in the other direction; the bottom of the box becomes smaller, and the top is enlarged. The orange assumes an almost round shape, the plate axis is almost horizontal, and the right side of the box is vertical.

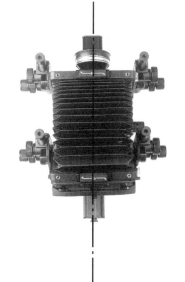

## BACK SWINGS LEFT

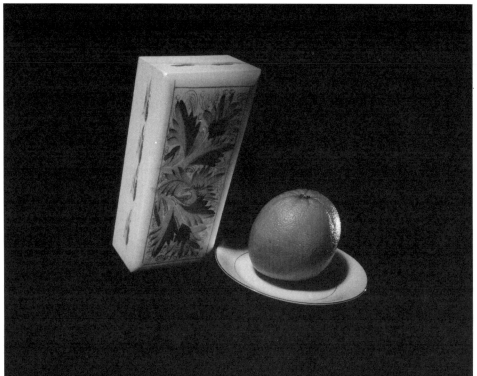

The camera back swings left, parallel to the box front. The most obvious change now is the way the top of the box shifts to the right. Also, the axis of the plate shifts and the orange looks as though it is about to roll off to the right. In all the other illustrations, the top of the orange is tipped over to the left, the result of adverse yaw.

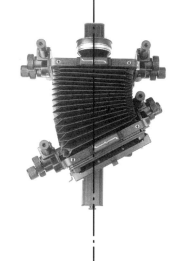

## BACK SWINGS RIGHT

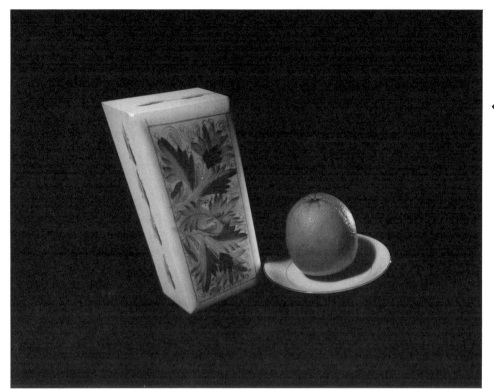

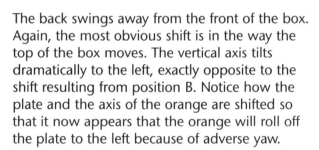

The back swings away from the front of the box. Again, the most obvious shift is in the way the top of the box moves. The vertical axis tilts dramatically to the left, exactly opposite to the shift resulting from position B. Notice how the plate and the axis of the orange are shifted so that it now appears that the orange will roll off the plate to the left because of adverse yaw.

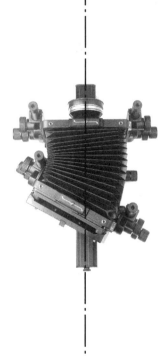

*Chapter Six*

# SETTING UP AND MAKING THE PICTURE

A major difference between working with a view camera and a roll-film camera is the complexity of setting up and operating the equipment. The view camera must be used with precision and an understanding of its controls in order for you to get the results that you want in your pictures. Not only must you operate the camera correctly, you must also set it up properly if you want to use the camera to its greatest potential.

The actual operation of the camera requires an extended series of settings and adjustments. When you use a modern 35mm camera, just about the only considerations you have to concern yourself with are pointing the camera and deciding when to press the shutter-release button. Film loading, ISO settings, shutter-speed and aperture selection, focusing, and the use of flash are all decided by the camera. It even rewinds the film when the roll is finished. That isn't the case with a view camera; each of these operations becomes your responsibility. Therefore, it is important for you to know and understand each of the individual steps in order to master your equipment.

## SETTING UP THE TRIPOD

The first order of business is to properly position and set up your tripod for the shoot. This is essential because you must make sure that the camera won't have to be moved again after the tripod is in position and the picture is set up. If you don't, you might have to realign the camera and readjust all the controls, thereby risking vibration and loss of image sharpness.

To begin, make sure the tripod legs are all together. Extend one leg section far enough so that the camera will be at the right height when it's mounted on the tripod. Stand the tripod upright on the single extended leg and then extend the other two legs until they touch the floor at the same length. If the floor is level, the tripod centerpost should be perfectly vertical. This is important because it means that when the camera is raised or lowered, it will go straight up or down and won't be shifted out of alignment with the subject. Keep in mind that there is a considerable distance between the mounting block and the lens, so it might not be necessary to extend the legs to their full height, particularly if you're photographing closeups or tabletop setups. If the tripod legs are composed of several segments, extend the uppermost section first, since it is the heaviest component and consequently the most stable. Then extend the others in descending order until each leg is at the right height. You can set the final camera elevation with the adjustable centerpost.

Next, mount the camera on the tripod head so that the monorail track is centered and aligned with the long axis of the platform. This will ensure that when the tripod's tilt or roll controls are used, the camera moves in the proper direction.

Before you start to set up the picture for the shoot, use the tripod controls to level the camera front to rear and side to side, using the bubble levels on the front and rear standards. Finally, center all camera swing, shift, and tilt controls in the neutral position.

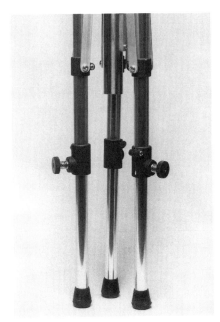

Make sure that the tripod legs are together in the closed position before you extend them to the required height.

If the tripod legs are composed of locking segments, extend the uppermost segment first. When that is in position and locked, extend the remaining segments of a leg in descending order until they are all set at the proper height.

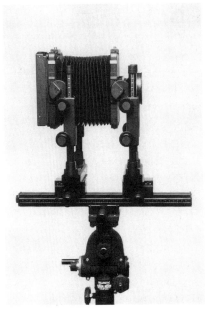

Mount the camera on the tripod head, and make sure that it is aligned with the center axis of the platform.

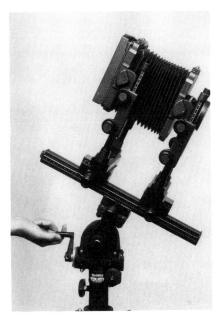

Check all pan and tilt levers to make sure that the settings move easily yet lock securely in place as needed.

When the tripod is fully extended, set all of the camera controls in the neutral position.

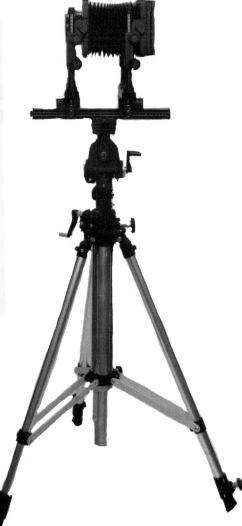

*Rewrite from Chapter 1.*

# FOCUSING THE IMAGE

The view camera's larger format offers the ability to focus even the smallest details with crisp precision. But focusing involves more than just getting some part of the subject sharp. It calls for getting the proper part of the image sharp and ensuring that there is the right amount of depth of field, and that it is correctly positioned.

The groundglass is the focusing screen on which you compose and focus the image. Most types of groundglasses have a half-inch grid of lines scribed on them. These lines aid in the composition and accurate alignment of parallel lines in the image. The groundglass, however, can cause frustration bordering on paranoia simply because it presents the image upside down and reversed. You must learn to focus and compose this way if you are to successfully manipulate the camera's controls. When you want to move the subject, you must move it in the opposite direction from that showing up on the groundglass. If you want to make any adjustments to the camera, the controls must be moved the opposite way from what you would normally expect. As discussed in Chapter 2, having an accessory reflex mirror will help overcome this problem. However, it is a good exercise in visual perception to learn how to read the image inverted and reversed.

In many view-camera models, the four corners of the groundglass are cut off. This design allows air to move in and out of the camera, thereby equalizing the pressure in the bellows that changes during focusing. If this pressure isn't equalized, the bellows could collapse, like a vacuum-cleaner bag, and cause a shift in the focus.

The cut corners of the groundglass also serve as viewing ports to make certain nothing obstructs the front of the lens or picture area. In some picture-taking situations, a compendium bellows is used to shade the lens or to serve as a filter holder. This compendium bellows is adjustable for use with different focal-length lenses. You can easily check to see if it cuts into the picture area by looking through the four viewing ports of the groundglass corners.

An auxiliary magnifier that can be held directly against the groundglass surface is a very helpful accessory for focusing on the groundglass, both in terms of sharpness and for composition. The magnifier enables you to see small segments of the image in great detail.

Because a groundglass is flat, the distance from the lens to the corners of the groundglass is greater than that from the lens to the center of the groundglass. Light rays, having farther to travel to reach the corners of the groundglass image, become more dispersed. As a result, the image is considerably brighter at the center than at the corners. This makes it difficult to see the image clearly when focusing with very slow lenses or when focusing with the lens stopped down in order to check depth of field. To aid in focusing, you can install a Fresnel lens on the groundglass of the camera. This accessory directs more light toward the corners of the groundglass, thereby evening the illumination across the whole image. Although the textured-pattern surface of the Fresnel lens breaks up the image, the center is clear so that the image can be precisely focused. A recent development that produces an even brighter and sharper image is the *Super-Sharp Focusing Screen*. It must be used in conjunction

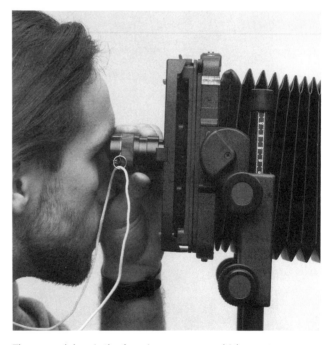

*The groundglass is the focusing screen on which you compose and check details of the subject. The groundglass has a grid of fine lines that help you keep verticals and horizontals parallel throughout the picture-taking process. An auxiliary magnifier can also be used on the groundglass for even greater focusing accuracy.*

with a Fresnel lens to balance the illumination over the entire groundglass.

The shiny surface of the groundglass compounds the difficulty of seeing and understanding the image. The groundglass reflects any light behind the camera; this washes out the image, making it almost impossible to see. To solve this problem, you should drape a piece of opaque black cloth over your head and the back of the camera. This *focusing cloth* creates a tent that eliminates most of the extraneous light. However, when you work under a focusing cloth, you might tend to get close to the groundglass and to look at only a small area at a time. It helps to move your head away from the groundglass while remaining under the focusing cloth. This position provides a better overall view and aids in judging relative brightness between different areas of the subject.

A useful accessory that is available for some view cameras is a wire frame that attaches to the back of the camera and over which is draped the focusing cloth. The frame holds the cloth up and out of your way so that you can more easily move your head around for a better look at the groundglass.

The preferred technique for focusing is to move the groundglass back and forth along its track until you stop precisely at the point where the image appears the sharpest and brightest. Under very dim lighting conditions, it is often easier to focus for image brightness than for image sharpness.

One of the simplest ways to see to focus is to shine a bright light on the subject. Generally, you illuminate a subject for a visual effect, but that doesn't mean there is enough light to accurately focus the image on the groundglass. When this happens, you can bring in a hot light and position it close to the subject. Focus, compose the image, check the depth of field, and then remove the light from the setup.

A technique some photographers use to get a brighter image on the groundglass is to cover the rough, or ground, side with a very light coating of oil. This fills up some of the pebbled surface of the glass, resulting in a smoother, brighter surface for focusing. The drawback, of course, is that dust and dirt tend to adhere to the oily surface and come into contact with the film. As such, you must be very careful if you decide to use this method.

## Focus and Depth of Field

An important point when focusing the view camera is to always check the depth of field by stopping the diaphragm down as you view the groundglass. You'll find that if you close the aperture and then look at the groundglass—particularly at very small openings—it is practically impossible to see what happened to the depth of field. The best approach is to get under the focusing cloth with the lens set at its widest opening. Then you have to reach around in front of the camera and slowly pull the lever and close the diaphragm. You'll soon discover that it takes practice to locate and operate the diaphragm lever while standing behind the camera, but that is the only way to do it unless you have a camera with diaphragm controls located at the back or an assistant who can operate the controls for you. By your stopping the lens down gradually as you watch, your eyes adjust to the decreasing amount of light being transmitted, giving you extremely accurate viewing. Once the required depth of field is achieved, stop the lens down one additional *f*-stop for insurance. Although one stop is insurance, a two-stop change doesn't equal more insurance. Remember, there is a dual tradeoff involved with the increased depth of field and small apertures: reciprocity failure if the exposure is longer than 1 sec., as well as loss of image sharpness because of diffraction.

## Back Focusing

Both the front and back standards on most view cameras can be moved along the monorail track; therefore, either standard can be used to focus the image. Image size is determined by the lens-to-subject distance. With handheld cameras, moving a short lens causes only a slight change in the lens-to-subject distance and has little effect on image size. However, the normal lens on a $4 \times 5$ view camera has a focal length of 6 inches, so the change in the lens-to-subject distance can be appreciable, particularly when you focus on a closeup subject. By your using the back standard to focus your view camera, this problem is completely eliminated. The correct technique calls for setting up the view camera so that the lens is at the proper distance from the subject to give the desired image size. Focusing is done by moving the groundglass back while the lens-to-subject distance remains constant.

## Shifting the Monorail

For greater focusing control when the view camera is either too close to or too far from the subject, move the entire camera closer or farther away by sliding the monorail back and forth along the tripod mounting block. When possible, you should make minor adjustments this way rather than by moving the tripod because the alignment of the image on the groundglass is not disturbed. Shifting the tripod would require raising or lowering the camera, which creates problems associated with realigning the image.

# STEP BY STEP: MAKING THE PICTURE

Making a picture with a view camera is not a simple process. The controls must be individually operated and repeatedly checked for correct positioning and setting before you actually make the exposure. If you leave one step out, you may wind up with a poor image, or worse, not get one at all. Some words of caution: all of the camera and tripod controls have locks on them. Use these locks to be sure that no change occurs in your settings either before or during the time you're shooting the picture. There is nothing more frustrating than having the camera back shift out of position when you pull out the springback to insert the film holder. But don't over-tighten them; these locks are quite efficient and require only a slight tightening in order to hold securely. The following procedure is the proper way to set up the camera and controls.

1. *Position the camera.* The camera position determines your perspective. Make sure that the camera is positioned so that the foreground and background of the subject have the desired size relationships.

2. *Put all camera controls in neutral.* Before you make any camera adjustments, center and neutralize all controls. Level the camera, front to rear and side to side, using the built-in bubble levels. Camera adjustments should always start from this neutral, "0" position. Open the shutter with the press-focus control, and set the aperture for the widest opening.

3. *Frame the subject.* Use the tripod centerpost to position the camera at the proper subject height. Center the image on the groundglass.

4. *Focus the camera.* Although both the front and back standards can be moved, the back is the one used for focusing. As discussed, if the back instead of the lens standard is moved, the lens-to-subject distance remains constant and the image size on the groundglass remains unchanged. Even a small movement of the lens can make a marked difference in subject size. This is particularly true with closeup photography.

5. *Select the proper focal-length lens.* With the camera positioned for the proper perspective, make certain that the lens covers enough of the subject from side to side and top to bottom. If you don't see enough of the subject on your groundglass, change to a shorter focal-length lens for a wider angle of view. If you see too much of the subject, select a longer focal-length lens with a narrower angle of view.

6. *Adjust the image size.* At this point, it might be necessary to make further adjustments in the image size by moving the camera either closer to or farther from the subject as needed. Try to avoid major movements of the camera because they will change the perspective. For minor adjustments, it is possible to slide the camera backward or forward in the tripod mounting block. If major adjustments have to be made, you'll have to move the whole tripod. Don't frame the subject too tightly. Leave yourself some breathing room so that you can crop the picture later if necessary.

7. *Make shape and focus corrections.* Adjust the swings and tilts to get the correct the image shape, and then position the plane of sharp focus to get the necessary depth of field.

8. *Recenter the image.* After adjusting the image shape and sharpness, you might need to recenter the image. Do this by using the camera back's slides, rises, or falls.

9. *Check depth of field.* While watching the groundglass, slowly close the diaphragm to make

sure that you have sufficient depth of field. Once everything appears sharp on the groundglass, close the aperture down one additional stop to compensate for any imperfections in the way you see.

*10. Check the image area.* Examine the groundglass carefully to make sure that nothing extraneous to the picture is visible. If you see something that shouldn't be there, remove it. If you're using a compendium bellows, check the four viewing corners of the groundglass to be certain that the compendium bellows doesn't obstruct the picture.

*11. Take an exposure reading.* Determine the correct shutter speed for the preselected aperture setting described in step 9. Whenever possible, take a reflected-light reading from an 18-percent gray card, or use an incident-light meter to get an average exposure. If possible, include the 18-percent gray card in the photograph. This makes it easy to accurately evaluate image density, contrast, and color balance in the processed negative or transparency.

*12. Determine the bellows factor.* If the camera is closer to the subject than eight times the lens' focal length, recalculate the exposure because of the increased lens-to-film distance. Whenever possible, readjust the exposure time rather than the aperture to keep depth of field constant. Try to limit exposure times to 1 sec. or less to avoid reciprocity failure (see the section on calculating the bellows factor on page 128).

*13. Set the shutter and aperture.* Release the press-focus control, and then make sure that the shutter is closed. Set the correct aperture number and shutter speed. Cock the shutter. It is a good practice to trip the shutter a couple of times to be sure that it's working properly.

*14. Insert the film holder.* Gently pull open the spring-mounted groundglass and insert the film holder. Be sure that the holder is pushed fully into the camera and properly positioned so that there is a light-tight seal between it and the camera back. Be certain that all camera and tripod lock screws are tight so that you don't shift the position of the back while inserting the holder. Check also that an unexposed sheet of film is facing the lens; the white or shiny side of

the slide in the holder indicates unexposed film.

*15. Remove the darkslide.* Before you pull out the darkslide, recheck the front of the camera to be sure that the shutter has been closed, that the shutter speed and aperture have been properly set, and that the shutter is cocked.

*16. Stop and wait!* This is a very important step. Don't proceed until any camera vibrations or movements have a chance to subside.

*17. Make the exposure.* Always use a cable release to trip the shutter. Pressing the shutter-release lever by hand can cause enough camera movement to destroy image sharpness.

*18. Replace the darkslide.* Be certain to turn the latch on the end of the holder so that the slide can't be pulled out accidentally. More than one piece of film has been ruined because the holder was pulled out of the camera before the darkslide was replaced.

*19. Check the darkslide.* When replacing the slide, be certain that the black side is facing out. This indicates that the film has been exposed. If you neglect this step, you can easily become confused and can make an unwanted double exposure on the same piece of film.

*20. Expose the reverse side of the holder.* Use exactly the same shutter and aperture settings and expose the second sheet of film. This enables you to process one sheet of film, make judgments about density, contrast, and color, and then adjust the development time for optimal image quality.

*21. Advance the film.* When using a roll-film holder, advance the film immediately after making the exposure. This prevents accidentally making a double exposure. With roll film, you can't process individual exposures to test for density and color contrast, so if time and film permit, bracket the exposure by one stop over and under for added insurance. This provides a range of densities so that you can select the one that is best suited to your needs.

*22. Check the focus.* Remove the holder. Open the shutter and diaphragm and recheck the focus, camera adjustments, and framing to make certain nothing shifted while you made the picture.

# Chapter Seven
# FILM AND EXPOSURE

All the effort you put into setting up a photograph can easily be wasted if your film and exposure choices are wrong. These elements are crucial to your final result; understanding how they affect the image will help you make the right decisions before you put any film in the holder. There are many factors to consider when choosing a film for a particular photographic situation. It is important to select the film type that will best fit the subject and the conditions under which it will be shot. Actually, the subject and the way the picture will finally be used often dictate the film selection.

Before choosing a film, you should first closely examine the wide range of film choices available, and then ask yourself some important questions. Will the picture be in color or black-and-white? If color, will you use negative or transparency film, and will you be shooting in daylight or tungsten-lighting conditions? Is the shooting location outside or in a studio setting? Do you need high-speed film to shoot in low-light conditions or to shoot fast-moving subjects where a high shutter speed is required to stop the action? Will it be better to use a fine-grain film so that you can make larger prints? Does the subject call for added contrast, or is it so contrasty that a film with a lower contrast might be preferable? Perhaps you need an instant check of the setup so that you can fine-tune the lighting or image positioning; in this situation, a Polaroid film is just

what you need. Or perhaps you simply want to experiment with paper negatives. As you can see, each problem dictates a variety of solutions.

Most major film manufacturers produce a large number of black-and-white and color films that satisfy the needs of almost all photographers. Although there are differences between the same film types of different manufacturers, they all make films that have similar basic characteristics. What's important is to understand and use those films that best satisfy your specific picture-taking requirements.

It is always a good idea to spend some time experimenting with a variety of films under the same conditions you'll experience when working. When you find a general-purpose film that you like, continue using it and become thoroughly familiar with the way it responds under different lighting and exposure conditions as well as with different types of subject matter. Experiment with other types of film on an occasional basis, or when you encounter a specific photographic situation that your preferred film is not right for. An important consideration is a film's availability. Select film brands and types that are generally available in the locations where you will normally be shooting. If you shoot large amounts of color film, it is wise to store an ample supply with the same emulsion, or batch numbers. This way you can always predict how colors will be rendered on film.

## FILM TYPES

Because most films must be handled in complete darkness, you must be able to identify what film you're working with and to load it into your film holder correctly so the light-sensitive side of the emulsion is pointed toward the lens. To aid this identification and orientation, manufacturers cut a

sequence of notches along one edge of the top of the film. These are called *notch codes*, and each manufacturer has a specific series of notches for each specific film it produces. The chart opposite is an illustration of film types and notch codes for films produced by the Eastman Kodak Company.

## KODAK Color Negative and Print Films for Process C-41

VERICOLOR III
Professional / 4106 (Type S)

VERICOLOR 400
Professional / 4028

VERICOLOR HC
Professional / 4329

VERICOLOR II
Professional / 4108 (Type L)

VERICOLOR ID/Copy / 4078

VERICOLOR
Internegative / 4112

VERICOLOR Internegative,
Type 2 / 4114

VERICOLOR Print / 4111

## KODAK Color Reversal Films for Process E-6

EKTACHROME 64
Professional / 6117

EKTACHROME 64T
Professional / 6118

EKTACHROME 100
Professional / 6122

EKTACHROME 100 PLUS
Professional / 6105

EKTACHROME 200
Professional / 6176

EKTACHROME
Duplicating / 6121

## KODAK Black-and-White Films

Commercial / 4127

Contrast Process
Ortho / 4154

EKTAPAN / 4162

Fine Grain Positive 7302

(Universal notch)

High Speed Infrared / 4143

KODALITH Ortho 2556,
Type 3

KODALITH Pan 2568

Matrix / 4150

Pan Masking 4570

Pan Matrix / 4149

PLUS-X Pan
Professional / 4147

Professional B/W
Duplicating / 4168

(Universal notch)

Professional Copy / 4125

ROYAL Pan / 4141

Separation Negative 4131,
Type 1

Separation Negative 4133,
Type 2

SUPER-XX Pan / 4142

Technical Pan / 4415

(Universal notch)

T-MAX 100
Professional / 4052

T-MAX 400
Professional / 4053

TRI-X Ortho / 4163

TRI-X Pan
Professional / 4164

# FILM LOADING

Most view-camera photographs are made on individual sheets of film rather than on rolls. The standard sizes for sheet film (in inches) are $2\frac{1}{4}\times3\frac{1}{4}$, $4\times5$, $5\times7$, $8\times10$, and $11\times14$. The two most widely used sizes are $4\times5$ and $8\times10$. (For sizes smaller than $4\times5$, many photographers prefer roll film in special holders.)

Sheet film is inserted in a two-sided film holder. Each side of the holder is covered by a darkslide that makes the holder light-tight and is removed only after the holder is inserted. The accompanying illustrations show how a cut-film holder is prepared for loading.

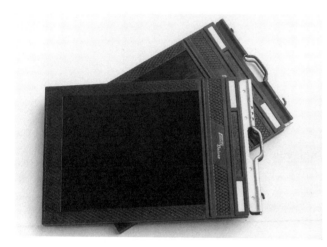

1. One side of the film holder contains unexposed film (the silver or white side of the darkslide should be facing out), and the other side contains film on which a picture has been exposed (the black side of the darkslide should be facing out). The latches on the end of the holders prevent the darkslides from being pulled out accidentally.

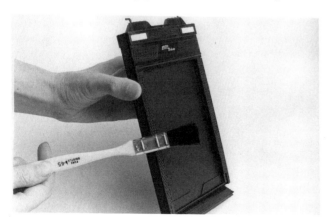

2. Cleaning the film holder before each use is essential because the smallest particles of dust

inside the holder can cause scratches or a pinhole that appear as spots or scratches on the final print or transparency. To clean the holder, remove the darkslides, open the flap at the bottom, and then tap the edge of the holder sharply with the edge of the cleaning brush. This dislodges any dust trapped in the slot at the top of the holder where the darkslide is inserted.

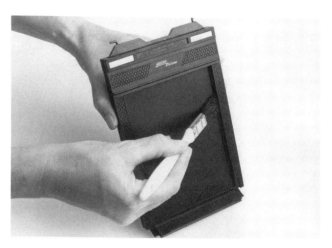

3. Carefully brush out the whole interior of the holder on both sides. Take particular care with the edge grooves that hold the film in place when it is loaded. A small bristle paintbrush does the job well.

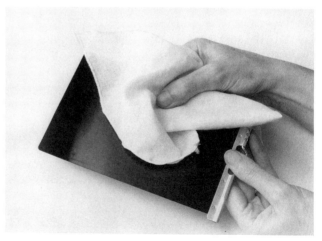

4. Use a soft cotton cloth or handkerchief to wipe the darkslide clean.

5. From this point on, you'll be working in complete darkness to prevent exposing the film. To load the film, open the film box; this consists of a top, a bottom, and a second bottom inserted into the first. The three parts of the box make a

completely light-tight film container. The film itself is sealed in a foil envelope, and comes in either 25 or 100 sheets of black-and-white, and 10 or 50 of color. Open the foil envelope from one end so that any unused sheets of film can be reinserted for storage. Identify the emulsion side of the film by finding the series of notches. When you hold the film in your right hand with the notches positioned in the manner illustrated, the emulsion side of the film faces up.

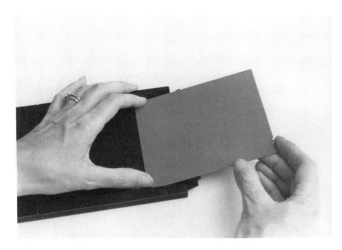

6. Use your forefinger and left thumb to guide the edge of the film into the grooves on each side of the film holder. These grooves keep the film flat and in the proper position in the holder. Note that the emulsion side is up, facing the open side of the holder.

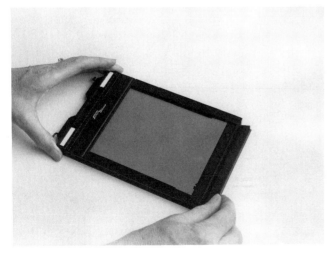

7. Once you insert the film, slip a fingernail under the end and try to lift the film up. This ensures that the film has actually slid into the grooves on each side of the holder. Finally, close the flap at the bottom of the holder to keep the fourth edge of the film flat.

8. After the film is loaded, insert the darkslide silver side out. This indicates that the film is unexposed. To facilitate identification in the dark, you can feel a series of readily noticeable notches on the silver side. Once you expose the film, reinsert the darkslide with the black side out; this indicates that the film is exposed.

9. Slip the darkslide into its slot in the holder and push it all the way into the groove in the bottom flap. Be sure that the silver side is out and that the end of the darkslide sits properly in the flap before turning on the lights.

# DETERMINING EXPOSURE

Film is composed of a light-sensitive layer of silver salts suspended on a transparent plastic base. When this material is exposed to light and then developed, the silver salts turn to a metallic silver. This metallic silver is black. When you make a photograph, the bright or light parts of the subject reflect a large amount of light onto the film and turn that part of the film black. A gray or less bright area gets less light so fewer particles of silver are exposed. These areas show up gray when the film is developed. Dark areas or black in the subject reflect little light and, therefore, few or no particles of silver in the film are exposed; these areas remain transparent.

To get a well-exposed image, you must expose the film to just the right amount of light. If you give the film too much light, the negative will be too dark and you won't have a picture. Conversely, if you give the film too little light, there will be little or no image and again you won't have a picture.

## Using Exposure Meters

To determine how to get a properly exposed image, you must measure the light falling on the subject. This is generally done with an exposure meter that has calibrated scales indicating a variety of shutter-speed and aperture combinations that will properly expose the film for the specific lighting condition.

The exposure settings indicated by the exposure meter are generally correct for average subjects under average lighting conditions; however, not all subjects are average, and at times you need to adjust the exposure settings differently from those called for by the exposure meter, as when you photograph small objects or shoot closeups.

When you make closeups, exposure is directly related to the distance between the lens and the subject. The closer you bring the camera, the less of the subject the lens sees and the larger that particular segment of the subject will appear on the camera's groundglass. This means that the light being reflected from this smaller segment is now spread over the entire sheet of film, and there is less light striking any one single area of it. In order to correctly expose the film in this situation, you must compensate for this and increase the amount of exposure called for by the exposure meter. You can do this either by increasing the opening of the diaphragm or increasing the length of the exposure time.

## Rule of the Inverse Square

The principle controlling this change in exposure is called the *Rule of the Inverse Square*. It states that the intensity of light falling on a subject is inversely proportional to the square of the distance from the light source to the subject. For example, if you make two photographs, one of a distant object and one very close to the camera, both under the same lighting conditions, there will be a considerable difference in the exposure of each. In the closeup, you need to move the lens away from the film in order to get the subject in focus. If you move the lens twice as far from the film as it was in the distant photograph, according to the definition of the Rule of the Inverse Square, the exposure must be adjusted inversely as the square of the distance. Having doubled the distance between the lens and the film, you must square that. Multiplying $2 \times 2$ calls for a four-time increase in exposure. This means opening the lens two stops or leaving the shutter open four times as long.

This need to increase the exposure time is called the *bellows factor*. This is the amount the exposure must be increased over what is called for by the exposure meter in order to correctly expose the film. The following is a very simple formula that can be used to recalculate the exposure for any specific lens-to-film distance. All you have to do is measure the length of the bellows. This is the distance from the film plane to the front of the lensboard.

$$\frac{\text{Bellows Length}^2}{\text{Focal Length}^2} = \text{Exposure Increase}$$

For example, here is how the bellows factor works using a camera with a 6-inch normal lens. After setting up the picture and getting the image in focus, you can assume that the measured distance from the front of the lensboard to the film plane is 12 inches. (The lens' focal length is engraved directly on the lens mount.)

$$\frac{BL^2}{FL^2} = EI \qquad \frac{12^2}{6^2} = EI \qquad \frac{144}{36} = EI \qquad 4 = EI$$

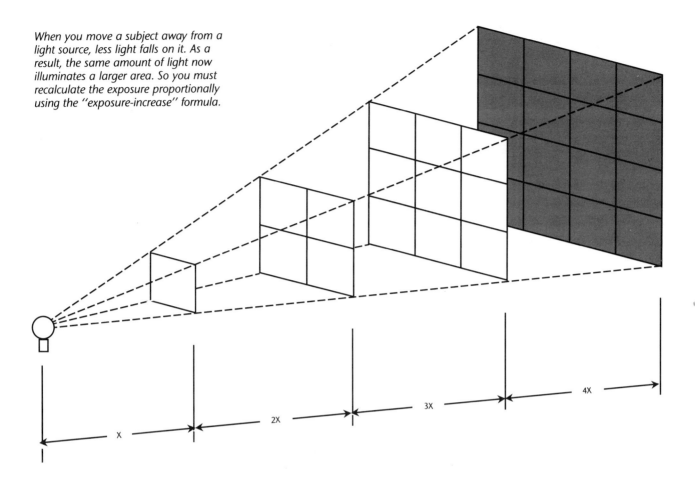

*When you move a subject away from a light source, less light falls on it. As a result, the same amount of light now illuminates a larger area. So you must recalculate the exposure proportionally using the "exposure-increase" formula.*

The exposure must be increased so that the film receives four times as much light as is called for by the exposure meter. Although generally used to calculate lighting factors, the Rule of the Inverse Square applies to many other situations. For example, you can use it to establish lighting ratios when setting up floodlights or electronic flash by indicating how far each of the lights must be positioned from the subject. It can also be helpful when you deal with focal length; if you double the lens' focal length, you'll cover one-quarter of the subject and the image will be four times as large.

Quite often when shooting closeup photographs, you'll be making the pictures to a particular degree of image magnification in relation to the size of the subject. In these instances, you can use the chart opposite to decide how much to increase the exposure.

| MAGNIFICATION | AMOUNT OF EXPOSURE INCREASE | NUMBER OF STOPS NEEDED FOR REQUIRED EXPOSURE INCREASE |
|---|---|---|
| 1/4 : 1 | 1.5 | 1/2 |
| 1/2 : 1 | 2 | 1 |
| 3/4 : 1 | 3 | 1 1/2 |
| 1 : 1 | 4 | 2 |
| 2 : 1 | 9 | 3 |
| 3 : 1 | 16 | 4 |
| 4 : 1 | 25 | 4 1/2 |
| 5 : 1 | 36 | 5 |
| 6 : 1 | 50 | 5 1/2 |
| 7 : 1 | 64 | 6 |
| 8 : 1 | 80 | 6 1/4 |
| 9 : 1 | 100 | 6 1/2 |
| 10 : 1 | 120 | 7 |

*NOTE: When using long exposures, check the reciprocity effect of the film being used*

*If you know the degree of magnification of the image in relation to the subject, you can use this chart to determine exposure increases.*

## RECIPROCITY CORRECTIONS FOR MOST BLACK-AND-WHITE FILMS

| INDICATED EXPOSURE TIMES (IN SECONDS) | APERTURE CORRECTION | TIME CORRECTION | DEVELOPMENT CORRECTION |
|---|---|---|---|
| 1/100,000 | 1 stop more | — | 20% increase |
| 1/10,000 | 1/2 stop more | — | 15% increase |
| 1/1,000 | No correction | No correction | Normal |
| 1/10 | No correction | No correction | Normal |
| 1 | 1 stop less | 2 seconds | 10% decrease |
| 10 | 2 stops less | 50 seconds | 20% decrease |
| 100 | 3 stops less | 1,200 seconds | 30% decrease |

## Exposure and Reciprocity

In the discussion on the relationship between aperture and shutter speed in Chapter 2, I pointed out that there is a reciprocal relationship between the size of the lens opening and the amount of time that the shutter must be left open in order for you to get the right amount of light on the film. The larger the aperture, the less time is needed to expose the film. Conversely, the smaller the aperture, the longer the exposure time must be. Refer to the chart above.

Since both aperture and shutter speed increase or decrease exposure by a factor of two, they have a one-to-one, or reciprocal, relationship. This fact, known as the *Law of Reciprocity*, means that in a given lighting situation it is possible to select a wide range of shutter-speed and aperture combinations. Each combination allows the same amount of light to enter the camera and correctly expose the film. If you change either the shutter speed or the aperture, you must make a reciprocal change in the other in order to keep the same exposure.

## Reciprocity Failure

In certain extreme circumstances, when the exposure time is either very short (above 1/1000 sec.) or longer than 1/2 sec., the one-to-one relationship between shutter speeds and f-stops breaks down. When this happens with black-and-white films, exposure must be increased and a change in development time is required to obtain the desired film density and contrast. Reciprocity failure with color films may include a color shift in addition to a change in density, so it is possible to compensate only by making test shots and by experimenting with color-compensating filters in advance to achieve the proper density and color balance. For this reason, it is wise to keep exposure times within the above-mentioned extremes in order to avoid making exposure and development adjustments.

# LIGHT FALLOFF

The corners and edges of a piece of film receive less light than the center. The reason for this is that the film's edges are farther from the lens than the center and consequently they are underexposed in comparison to the center. This is called *light falloff*. When working with long lenses, you'll find that the difference is negligible and has little effect on overall image density. With normal lenses, the difference is more noticeable, particularly when you use larger film sizes. With extra-wide-angle lenses, the problem is much more acute. The amount of light falloff can be more than a one-stop exposure difference between the center and the edges of the film.

Negative films have a built-in correction for light falloff because enlarger lenses suffer from the same falloff problem, but in reverse. The corners of the film are farther from the lens than the center; therefore, the light falloff produced by the enlarger lens compensates for the extra density resulting from the light falloff of the camera lens.

## Center Filters

There isn't much you can do about light falloff for color-transparency films unless you are willing to spend a great deal of money. One way to get around the problem is to use a center filter. This type of filter is clear at the edges and has a center graduated neutral-density area that holds back just enough light to compensate for the difference in exposure from the edges to the center. But there are two drawbacks associated with using these filters. First, they add neutral density to the lens; therefore, you must either work with a wider aperture or increase the exposure time. The second drawback can be much more troublesome. For example, a center filter to fit a 90mm *f/5.6* lens costs about 380 dollars. With such average prices, you must decide whether the number of times you'll use the lens is worth the expense.

There is one compensation, however, that makes up for the technical fact that the edges of the transparencies are underexposed. Aesthetically, a color photograph generally looks better if the edges are slightly darker than the center is.

Light falloff is evident in the corners and edges of this paper negative.

## Chapter Eight

# EXERCISES

Each of these projects demonstrates common creative and technical problems that view-camera photographers continually encounter in their work. The exercises are presented in a sequential order, starting with the most basic image manipulation, and evolve into more complicated examples of photographic situations requiring a combination of camera movements.

Every time you control the shape of an object by swinging the camera back, you're actually distorting that shape—in effect changing its perspective or size relationships—to make it look the way you want it to. Every time you position the plane of sharp focus in one area of the picture, something else is thrown out of focus.

You should also keep in mind that the way the human eye sees and the way the camera lens sees are quite different. When you look at a subject, the size relationships between various parts of the subject are present, but your eye and mind tend to cancel out these differences because you know what the shape actually is. Consequently, the subject's appearance seems normal. When you look up at a building, the lines really do converge and the building does appear to be tipping backward. You subconsciously compensate for this and, therefore, are unaware of the apparent backward tilt or the linear convergence. When you look at parallel lines that converge on a horizontal plane, they also seem normal to you and you give them no thought. However, when you see the effect of these same converging lines in a photograph, they become quite apparent. This is especially true of vertical converging lines; the subject appears to be toppling backward in the image. This also happens when you photograph a subject with a wide-angle lens from an extremely close camera position; a perspective of sharply converging lines results. As such, you find it necessary to make corrections to the image although what you're actually doing is distorting the image in order to make it appear normal.

Another consideration is the different ways the human eye and the camera lens record a scene.

Although the eyes are aware of objects and movement over an almost 180-degree range, the only area where the image is actually sharp is the specific spot the eyes are focused on. In addition, this is true only when the eyes are still, not moving from one area of the scene to another. Areas even just a fraction of an inch away either vertically or horizontally aren't in sharp focus, and areas farther away are even less sharp. The reason you're able to see a subject sharply is because your eyes continually dance around over its surface, examining numerous individual areas. The eyes see clearly only when they stop on discrete spots; they can't do that when they are in motion.

For this same reason, the human eye lacks the ability to record extensive depth of field. A simple test proves this. Hold a finger up in front of you and look at it. As you do so, you must consciously prevent your eyes from shifting to the background. If you do this test carefully, you'll realize that only your finger is sharp; the background is blurred because you're seeing it with peripheral vision. However, if your eyes shift to the background, your finger will become unsharp. The human eye can see only a single spot sharply at one time.

The view camera's unique ability that enables you to control not only the shape of the image but also the areas that will be in sharp focus makes it a powerful creative and technical tool for solving visual problems. Keep in mind that a flat surface is flat, whether it is as small as a painting or as large as the side of a building. A building is simply a large box, and the manipulation of the camera controls to get the sides parallel and the various surfaces in sharp focus is the same as that used for shooting a cereal box.

Remember, the exercises included here are in sequential order from the most basic to the most complex. Each successive project is an amalgam of what went before; as a result, the best way to learn how to use the view-camera controls to solve visual problems is to complete the exercises in order.

# PHOTOGRAPHING A FLAT SURFACE AT AN ANGLE

## Problem:

To photograph a flat subject at an angle and have the subject sharp from one end to the other.

## Solution:

Utilize the Scheimpflug effect by tilting the lensboard until the film plane, the lens plane, and the subject plane all meet at a common point. This will result in a sharp subject plane, with the lens at its maximum aperture.

1. Place all camera controls in the neutral position and make sure that the lens and back standards are parallel.

2. Tip the camera down so that you can see the entire subject on the groundglass.

3. Bring the subject plane into sharp focus by tilting the lens toward the subject and turning the focusing knob at the same time until everything is sharp.

4. Once you establish the plane of sharp focus, stop down the lens to increase depth of field. Depth of field will be shallower near the camera and more extensive farther away from the camera. It is possible to reposition the plane of sharp focus simply by refocusing the camera back. This can be useful when the subject isn't perfectly flat, such as when you photograph the pages of an open book, and you want sufficient depth of field to ensure that everything will be perfectly sharp when you stop down the lens.

Because the plane of sharp focus is at an angle to the subject plane, the part of the subject in sharp focus is limited to the depth of field made possible by using a small aperture.

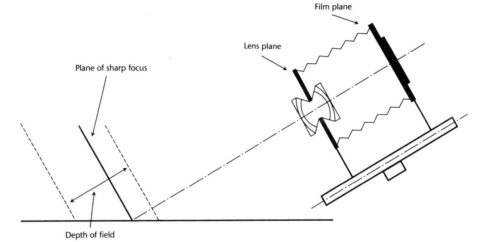

Tilting the lens so that the lens, film, and subject planes converge at a common point puts everything on the subject plane in sharp focus.

By using the Scheimpflug Effect, the lens, subject, and film planes all meet at a common point. As a result, the subject plane and the plane of sharp focus coincide, and the entire subject is in sharp focus.

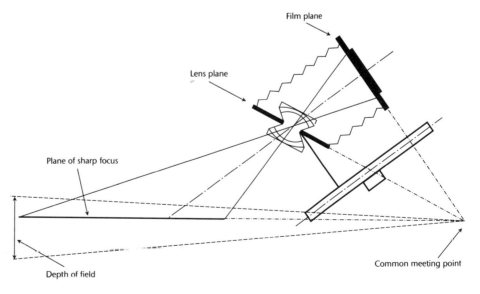

# PHOTOGRAPHING A FLAT SURFACE

## Problem:
To photograph a flat, rectangular subject, so that the entire image is in focus and all vertical and horizontal lines are parallel.

## Solution:
If the lens plane, the film plane, and the subject plane are all parallel, the subject's sides will be parallel. In addition, the subject will be in sharp focus, even at wide apertures.

Most copying is done on a vertical copystand. This device ensures that all three planes are parallel. The only adjustments you have to make are to raise or lower the copystand in order to properly frame the work and then to bring the image into sharp focus. If such a stand isn't available, you can copy the subject—such as a document—by hanging it on a wall.

1. Tape the subject to the wall at approximately eye level. The image on the groundglass is usually upside down, so you might want to start out with the subject inverted. It will then be right side up in the camera and, consequently, easier to work with. A convenient way to align the subject is to draw a large cross on the wall and to center the subject both horizontally and vertically.

2. Position the lights. Because copying generally means working close to the subject, it is easier to position the lights and calculate the exposure before you set up the camera. The lights should be of equal intensity, at the same height, and positioned at a 45-degree angle to the subject.

3. Balance the illumination. The background material should be even-toned. Take a reflected light reading from the background at all four corners. These four meter readings should be the same. If they are, you'll know that the illumination is even across the entire subject. If they aren't, reposition the lights until they are. To find the correct exposure, use a gray card and reflected-light meter or an incident-light meter.

4. Position the camera. All controls should be in neutral, and the camera should be leveled using the bubble levels on the film and lens standards. Also, the camera should be high enough so that the document is exactly centered both vertically and horizontally with the back and lens planes parallel to its surface. Move the camera close enough so that the subject almost completely fills up the groundglass, and use the camera back to focus the image.

If these conditions are met, the parallel lines of the subject will be parallel, and it will be in sharp focus with the lens wide open. You can check this by comparing the lines with the grid on the groundglass. If there are converging subject lines, the camera isn't centered on the subject and the back isn't parallel.

5. Measure the length of the bellows, and calculate the increase in exposure over what the light meter calls for (see page 128 for the bellows-factor equation).

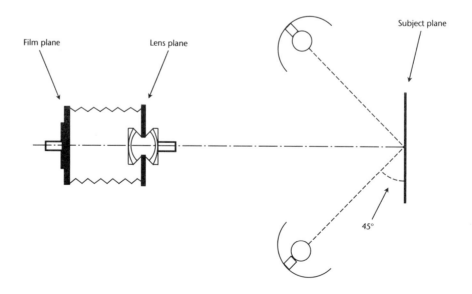

*To record parallel lines in the final picture, the lens, film, and subject planes must all be parallel. To ensure that the illumination is even, the lights must be at an equal distance from the subject, at the same height as the subject, and angled toward the subject at a 45-degree angle.*

Film plane    Lens plane    Subject plane    45°

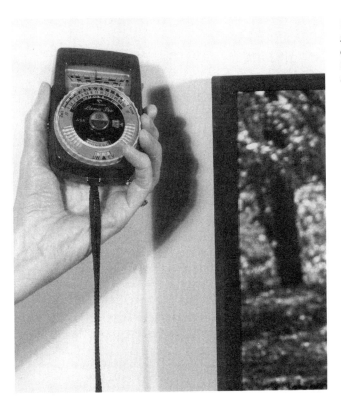

When photographing a flat surface, you should take a reflected-light reading from all four corners of the background. Adjust the lights if necessary until the four readings are the same.

The horizontal edges of this picture of a picture (above) aren't parallel because the camera was set up to one side of the subject rather than centered on it. To achieve accurate renditions of flat subjects (right), make sure that the camera back, subject, and lens plane are parallel.

# PHOTOGRAPHING A BOX OR BUILDING FROM GROUND LEVEL

## Problem:

To maintain both parallels and sharp focus in two planes.

## Solution:

This is an extension of the copying project in that the objective is to keep the camera and subject planes parallel so that the lines in the subject are parallel. Next, the plane of sharp focus is repositioned in order to utilize maximum depth of field.

1. Select a camera position that will give you proper perspective, and select a focal length that will provide the necessary angle of view to cover the subject from that position.

2. Neutralize all camera controls; then level the camera, using the bubble levels so that both the back and lens planes are vertical and parallel to the box.

3. From this ground-level camera position, the entire subject might not be visible on the groundglass. If possible, avoid tilting the camera up to cover the subject; raise the front and lower the back instead. This way the back and lens planes remain parallel to the subject plane.

If you can't raise the lens and lower the back far enough to cover the subject entirely, you'll have to tilt the camera up; it will then be necessary to realign the back and front standards so that they are vertical. The parallel lines in the subject should be parallel on the groundglass. Caution: unless you're working with a camera that has bottom tilts, don't swing the back or you'll induce adverse yaw.

4. With the lens raised and the back dropped, swing the lens toward the main surface of the box in order to utilize the Scheimpflug effect. Once the front plane of the subject is in focus at the widest aperture, refocus in order to shift the plane of sharp focus behind, and parallel to, the front plane.

5. Focus approximately one-third into the subject plane in order to utilize the full depth of field when the lens is stopped down. Stop down the aperture and watch the depth of field increase. When it is perfectly sharp from front to back, close the aperture one additional stop for insurance.

6. Check the exposure meter for the proper shutter speed for this aperture. If you're making a closeup, recalculate the exposure to compensate for the bellows factor.

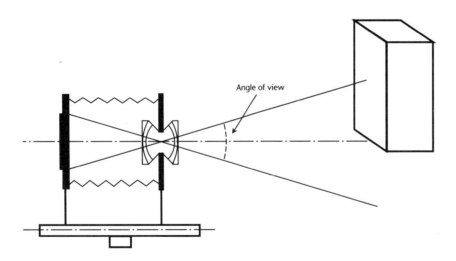
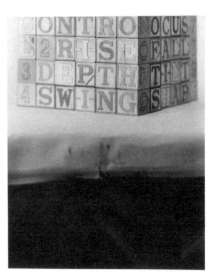

*If the camera is to one side of the center of the subject, the parallel lines won't appear parallel in the final image. In addition, any imperfections in the print surface will be more apparent, as seen here.*

SIDE VIEW

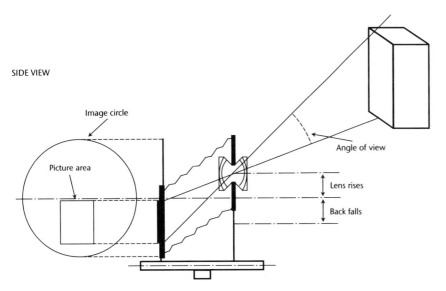

Image circle

Picture area

Angle of view

Lens rises

Back falls

When the camera is set up on ground level, it sees only the lower part of the building but a great deal of the foreground. By raising the lens and dropping the back, you can shift the position of the image on the image circle so that the lens sees more of the upper part of the box and less of the foreground. If the image circle is large enough, it is possible to record the entire box.

TOP VIEW

Plane of sharp focus

Plane of sharp focus

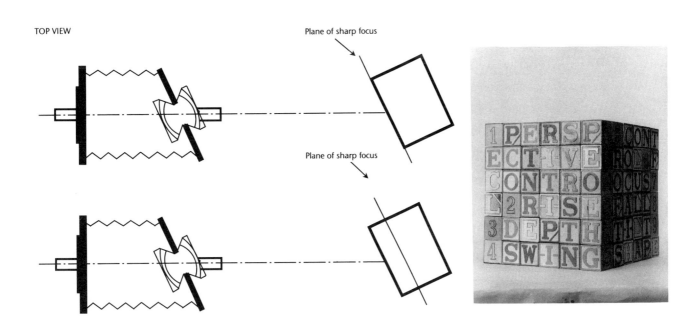

If the camera is tilted up in order to cover the entire box, then both the back and the lens will no longer be parallel to the front surface; also, the parallel lines of the box will converge and only part of the front surface of the subject will be in sharp focus. To make these surfaces parallel, tilt the lens and film planes upright so that they are parallel to the surface of the box.

# Photographing a Box or Building from Above

## Problem:

Essentially, there is no difference between this exercise and the preceding one. The two-surface subject will most likely be architectural because of the ground-level camera position. Shooting from above will probably apply to a studio situation, such as the top, front, and side of a box, or to some product.

## Solution:

The steps are exactly the same as those in the preceding project, but there are some considerations that you must keep in mind. The first is perspective. In order to get a large image on film in a studio situation, you might be tempted to bring the camera in close to the subject. If the subject is small and you're using a normal lens on the camera, the perspective may be exaggerated; this could make its shape look strange. This is why many studio-based photographers use either a 210mm or a 240mm lens as their standard lens on a 4 × 5 view camera. These lenses enable them to capture a large image of small subjects without the distorted perspective caused by being too close to the subjects.

Your second consideration must be the camera height above the subject; the higher it is, the more likely there won't be enough fall in the lens and rise in the back to cover the subject. If you tilt the camera down and then swing both the lens and back to establish the plane of sharp focus, adverse yaw will occur. Unless you are working from a layout that calls for a high angle and an extreme downward perspective, avoid positioning the camera too high.

# PHOTOGRAPHING A COMBINATION OF VERTICAL AND HORIZONTAL PLANES

## Problem:

To maintain parallels in the vertical subject plane while keeping both the horizontal and vertical planes in sharp focus. If you tilt the back and lens upright so that the parallels in the vertical part of the subject remain parallel, then the plane of sharp focus will be parallel to that surface and the horizontal part of the subject will be out of focus. Conversely, if you tilt the lens to make the horizontal surface sharp, then the vertical part of the subject will be out of focus.

## Solution:

Use back swings for shape control and parallel lines in the vertical part of the subject, and use lens tilts to establish a plane of sharp focus that will utilize all potential depth of field; this will get as much of the subject as possible into sharp focus. This positioning of the plane of sharp focus is a compromise: it cuts through both parts of the subject. If the plane of sharp focus is properly placed, most of both subjects will be sharply focused when you stop down the lens.

1. Position the camera at the proper distance to establish the desired image perspective. Set all camera controls in their neutral, centered position. To see both the horizontal and vertical parts of the subject, the camera will generally be above the subject and tilted down so that the entire subject can be seen on the groundglass.

2. Erect the back standard until it is vertical. This will make the planes of the subject background parallel.

3. Establish an imaginary plane of sharp focus. This plane should lie at an angle to the vertical as well as horizontal planes of the subject. The plane of sharp focus will pass through the vertical surface approximately one-third of the way down from the top of the subject, and one-third of the way into the horizontal plane of the subject. On the groundglass, the only areas of sharp focus in this imaginary plane will be where it intersects the vertical and horizontal planes of the subject.

4. Check the groundglass while stopping down to increase the depth of field. With the plane of sharp focus at an angle to the camera, the depth of field won't be uniform; because it becomes much greater at a distance than it is in the foreground since depth of field increases above and below the plane of sharp focus, both the horizontal and vertical planes will be sharp.

If there isn't enough depth of field or if the plane of sharp focus isn't correctly positioned, the area that might not be perfectly sharp is where the two planes intersect.

5. If the foreground isn't perfectly sharp, adjust the focus so that it is because objects that are close appear sharper than those that are farther away. As such, background areas that aren't as sharp as those in the foreground are less noticeable than foreground areas that aren't as sharp as those in the background.

6. Make the exposure.

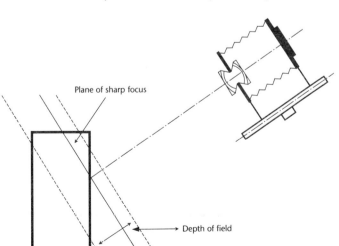

Plane of sharp focus

Depth of field

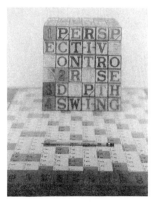

*If the camera is tilted down, the plane of sharp focus is perpendicular to the axis of the lens and there isn't enough depth of field to en-sure that both the horizontal and vertical components of the subject are in sharp focus.*

*Tilting the lens to utilize the Scheimpflug effect ensures that the horizontal plane is in sharp focus. Stopping down the lens increases depth of field and makes the bottom of the vertical component of the subject sharp. But the upper part is out of focus.*

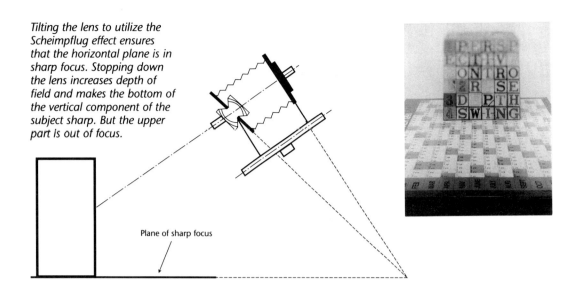

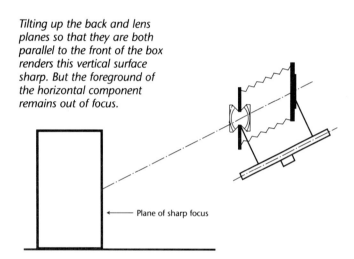

Plane of sharp focus

*Tilting up the back and lens planes so that they are both parallel to the front of the box renders this vertical surface sharp. But the foreground of the horizontal component remains out of focus.*

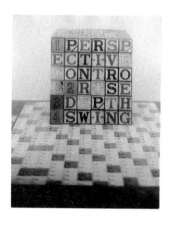

← Plane of sharp focus

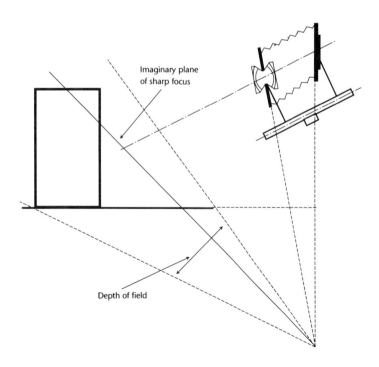

Imaginary plane of sharp focus

Depth of field

*Tilting the back so that it is upright and parallel to the front of the box ensures that this surface is rendered with parallel lines. Then by establishing an imaginary plane of sharp focus that passes through the horizontal and vertical surfaces, you can utilize the Scheimpflug effect to take advantage of the greater depth of field in the distant part of the subject. This renders both the horizontal and vertical components sharp.*

# PHOTOGRAPHING A SUBJECT WITH TWO INCLINED PLANES

## Problem:

To photograph an inclined plane that is skewed, or tilts both to the side and from front to rear.

## Solution:

In this shooting situation, the plane of sharp focus can be tilted toward the side as well as from back to front. This can be readily accomplished by tilting and swinging the lens at the same time. This camera solution, in essence, utilizes the Scheimpflug effect in two inclined planes.

1. First, level the camera, and then neutralize all controls before tilting the camera down to frame the subject.

2. This is a two-part correction. First, tilt the lens so that the inclined plane from front to rear is brought into sharp focus (the Scheimpflug effect).

3. Second, swing the lens so that the inclined plane is in sharp focus from side to side.

4. Make the exposure.

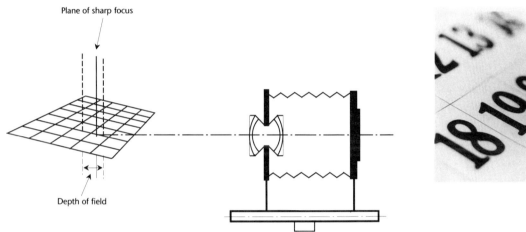

*When you photograph a subject with a skewed plane with the camera controls in the neutral position, the resulting depth of field ensures that only a narrow band of sharp focus is at an angle to the inclined surface.*

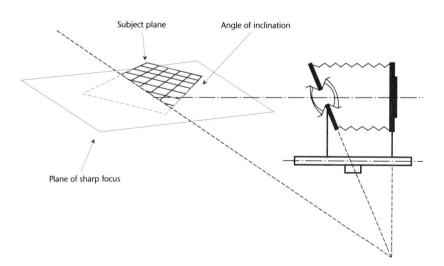

*Tilting the lens establishes sharp focus along one plane of the subject. But this plane is still at an angle to the subject plane.*

*Swinging and tilting the lens tips the plane of sharp focus so that it lies on the surface of the subject plane. The result is an image that is sharply focused from front to rear.*

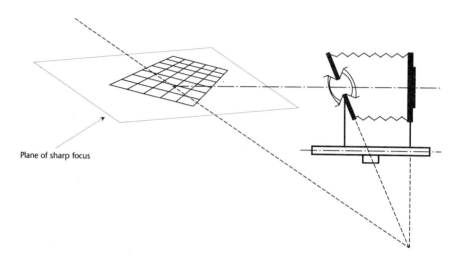

Plane of sharp focus

# INDEX

**Harvey Shaman** has been involved with photography since he first encountered it in Japan at the end of World War II. He specializes in editorial, advertising, industrial, and aerial photography. He teaches photography at the Fashion Institute of Technology in New York, and has written and illustrated many articles for such publications as *Popular Photography, Time, Reader's Digest, Forbes,* and *Popular Mechanics,* among others. Shaman is the co-author of the book *100 Camera Projects.* He holds a B.S. degree from West Virginia University and an M.A. in photojournalism from the State University of Iowa.